READ THIS IF YOU WANT TO BE GREAT AT DRAWING.

LAURENCE KING

Published in 2017 by
Laurence King Publishing Ltd
361–373 City Road
London EC1V 1LR
e-mail: enquiries@laurenceking.com
www.laurenceking.com

This book was designed and produced by Laurence
King Publishing Ltd, London.

A catalogue record for this book
is available from the British Library.
ISBN: 978-1-78627-054-2

Read This if You Want to Be Great at Drawing is
based on an original concept by Henry Carroll

Design: Maria Hamer
Picture research: Ida Riveros
Illustrations: Selwyn Leamy
Vector line drawings: Akio Morishima

Printed in China

READ THIS IF YOU WANT TO BE GREAT AT DRAWING.

SELWYN LEAMY

Contents

Everyone can draw 6

STARTING
Relax. You're only looking 9
Don't think, do(odle) 10
Simple is effective 12
Be free, be fluid 14
Go over the top 17
Keep it brief 18
 Technical Tangent:
 Get a grip 20
Draw it in silhouette 24
Remember, remember 26
Let there be lines 28
Don't look down 30
Everyone's a model 33

TONE
The science of the solid 35
 Technical Tangent:
 Drawing tools 36
Don't be afraid of the darks 41
Look for the shapes 42
Fill it up 45
Get cross (-hatching) 46
Wrap it in a line 49
Go dotty 50
Make it smooth and seductive 52
Start in the dark 55
Be dark and moody 56

ACCURACY

Keep it real	59
Plan it, draw it	60
Find your angle	62
Use a measured approach	64
Technical Tangent:	
Keep things in proportion	66
Engineer your drawing	68
Technical Tangent:	
Puzzle it out	70
Face facts	72
Shape the things to come	74
Accentuate the negative	76

PERSPECTIVE

It's all an illusion	79
Technical Tangent:	
Get some perspective	80
Get to the point	83
Approach from an angle	84
Get a little closer	87
Take me higher	88
Be deep, really deep	90
Fade into the background	93
Bend the rules	94
Bring it to the surface	96

EXPLORE

Find your own way	99
Technical Tangent:	
What to draw?	100
Make your mark	102
Capture your world	104
Record the detail	106
Find your happy accident	108
Tell your own story	111
Push your boundaries	112
Be a serial drawer	115
Mix it up	116
Re-use and deface	118
Take it off the page	120
Be brave, be simple	123

Index	124
Acknowledgements	126
Credits	126

Everyone can draw

I'll prove it. Grab a pencil and sign your name.

SIGN HERE

That's a drawing. And better still, it's a drawing with a style! Tight and precise or big and bold, neither is better or worse. Just different. And what you've just drawn is what comes naturally to you. Every drawing starts by putting a mark down on paper. Whatever it is, it doesn't matter because you're expressing your creative freedom. You can keep your drawings private and personal, or show the world. It's up to you.

In this book there are 50 different artists, all with very different ways of seeing and drawing the world. By understanding the ideas behind their drawings you'll feel more confident about making your own. Some you'll love and some you might think look difficult or complicated. That's only natural, but looking at other artists' work is how we learn and improve.

This book will give you a glimpse of the huge scope and range that drawing has to offer. It will introduce you to the practical skills and techniques that will allow you to explore these different avenues. But there are two things you need to remember:

- not every drawing you do is going to be a masterpiece. Even the masters have their off days.
- drawing is a life-long practice. The more you do, the better you'll get, and in the end you'll find your own way. This is only the start.

This can all be frustrating when you're starting out. But remember, above all else, drawing is fun and, once you get going, totally addictive. As Pablo Picasso once said:

'To know what you want to draw, you have to begin drawing...'

So get a pencil and some paper and start drawing.

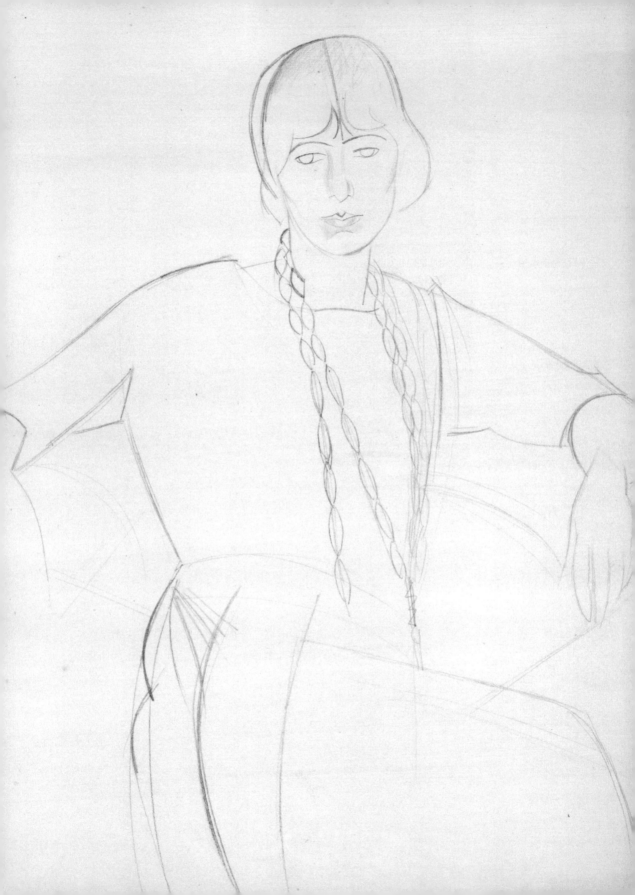

Starting

RELAX. YOU'RE ONLY LOOKING

How many times have you said that you can't draw? If you have, don't. This is giving up before you've even started and it means the biggest barrier to learning to draw is yourself. The best way to get rid of this barrier is to relax.

Relaxing and not worrying about your drawing is easier said than done. In this section I want you to accept that your drawings won't always look quite how you think they will, or how you would like them to. Try to switch off the part of your brain that has preconceived ideas about what a drawing should look like. These drawings are about just doing it, not about what they look like. It's the process not the product that's important.

As you start to relax you will worry less about how you're drawing and look more at what you are drawing. And the more you look, the more you'll start to see things differently.

Seated Woman with Beads
Wyndham Lewis
c. 1923

Don't think, do(odle)

Matt Lyon's doodle is an explosion of spirals, squiggles, shapes and shading. It may not look like any doodle you would do but that's because everybody's doodles are different. They're simply what we draw when our brain is switched off, or at least occupied by another task, like chatting on the phone.

This type of drawing is about being free, so just let it evolve and take you by surprise. It doesn't matter what it looks like in the end because, hey, it's just a doodle, so relax and have fun. For Lyon, however, the freedom of the doodle provides a starting point for what ends up being an arresting graphic artwork.

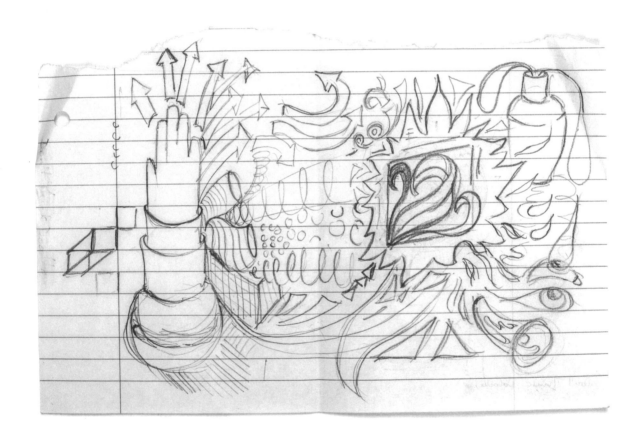

You can draw like this anywhere and on anything. There is no right or wrong with doodling, as everyone's doodles really are different. This is your artistic playground to do whatever you want. Create a crazy-looking character or a symphony of squiggles – it's all fine because it's just a doodle.

Taxonomy Misnomer
Matt Lyon
2007

For another example:
Mattias Adolfsson, p.107

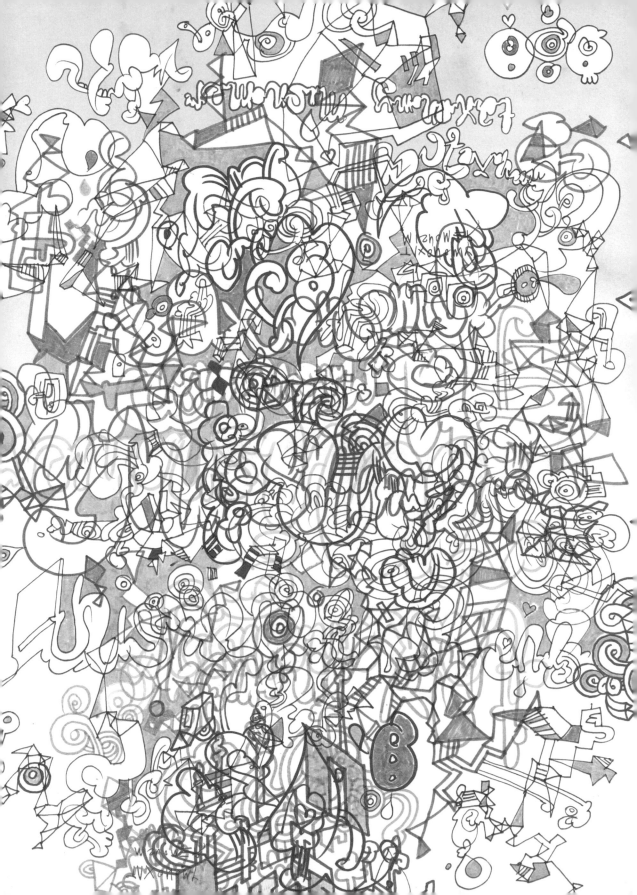

Simple is effective

Go to New York and I guarantee that you'll see this flower while walking through the chaos of billboards, buildings, cars and crowds. Whether painted on the side of a ten-storey building or printed on a tiny sticker, the motif's vivid simplicity makes it stand proud, like a reassuringly consistent voice in an ever-changing city.

The work of street artist Michael De Feo, this flower may look simple, but he would've drawn it over and over again in his studio. And only when he found just the right gentle curve for the stem and playful unevenness for the petals would he have gone out and planted it around the city.

Drawings don't have to be complicated or elaborate. It's a simple step from the freedom of a doodle to a crafted and elegant drawing like De Feo's.

Take an element of your doodle from the previous exercise and refine it by repeatedly drawing it, gradually distilling it down to its simplest, most essential form.

Flower Icon
Michael De Feo
1994–present

For another example:
Pablo Picasso, p.122

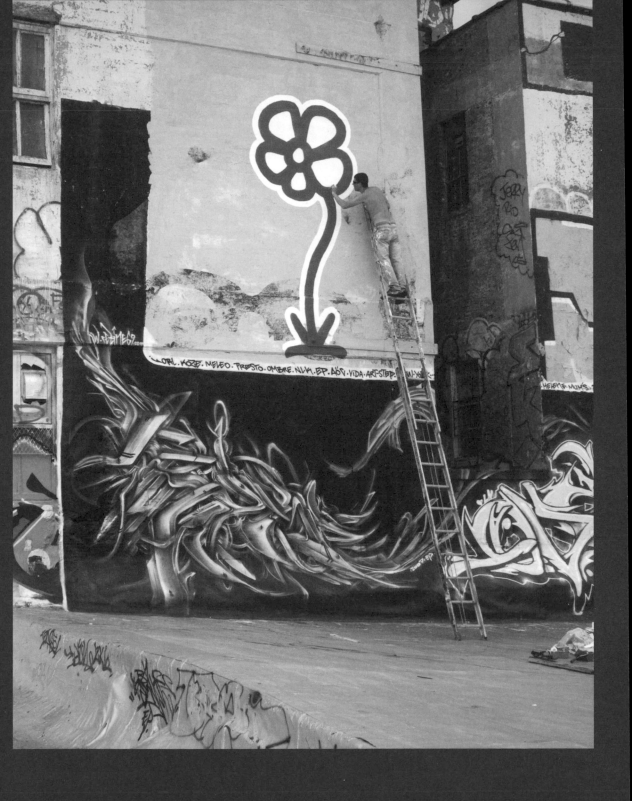

Be free, be fluid

Boris Schmitz's drawing is made with one continuous line, like a long piece of wire that shapes its way around the features of the girl gazing back at us. It's a sensuous drawing that captures her pose and her smouldering expression with freedom and fluidity.

Schmitz isn't afraid to let the line double back on itself, or to cut across the face, because these lines all help describe his subject. This type of drawing is like taking a line for a walk. You're in control but you have to think on your feet and keep your eyes locked on your subject.

Try drawing your hand with just one line.

- **Keep your pencil constantly on the page. It will help you to look more closely at your hand.**
- **Allow the line to move over the whole form of the hand, like the contours on a map, describing its entire shape.**
- **Don't get stuck, just keep your pencil moving and try to remain intuitive.**

Gaze 466
Boris Schmitz
2016

For other examples:
Ellsworth Kelly, p.31
Gregory Muenzen, p.32
Pablo Picasso, p.122

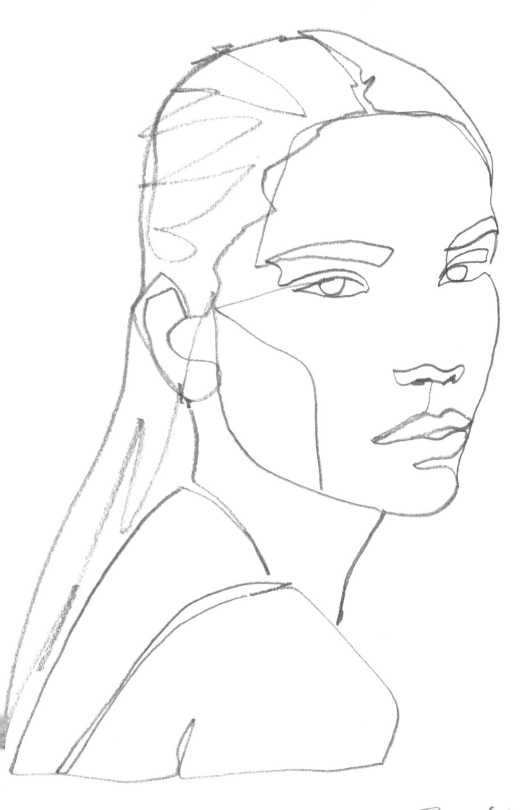

Boris Schmitz 2016

Go over the top

Being too precious about your drawing is paralyzing. See here how Gary Hume draws different flowers, one on top of another. Layers of petals, stems and stamens intertwine beautifully and it's hard to decipher where one flower ends and another begins.

Hume is excited by process – the process of images emerging from the surface with no reference to or room for storytelling, whether it's his large-scale paintings on aluminium or vigorous charcoal drawings on paper.

Working over the top of your drawing fragments the image, allowing you to catch only glimpses of the drawings underneath as they build up on each other. Your end product will be more than the sum of its parts.

Drawing directly on top of the drawing you've just done might sound like a terrible idea, but it frees you up from the anxiety of putting a mark in the wrong place and it lets you be far more expressive. And, in the end, it can create something that's visually exciting and has real energy.

Untitled (Flowers)
Gary Hume
2001

For another example:
Matt Lyon, p.11

Keep it brief

Eugène Delacroix believed that a true artist should be able to draw a man falling from a window before he hit the ground. This may sound extreme but the idea of the *croquis succinct*, or quick sketch, had a big influence on modern-art heavyweight Henri Matisse and helped him develop his distinctive style. This drawing by Matisse was done incredibly quickly. He honed down to the most important features of the scene, and dispensed with all unnecessary details.

The simplicity of this drawing is similar to that of Wyndham Lewis's drawing at the beginning of this section. In both, less is definitely more. Lewis's drawing is the more considered, but both condense the scene down to its most fundamental parts. With his economy of line, Lewis is able to simplify the complex form of the figure into a series of arcs and curves, while Matisse evokes a church in a Moroccan setting with just a few, deft well-chosen strokes.

Spending too long agonizing over the detail can ruin the freshness of a drawing. Force yourself to be swift and decisive. Move on even when you feel something may not be exactly right.

Church in Tangier
Henri Matisse
1913

For other examples:
Wyndham Lewis, p.8
Gregory Muenzen, p.32

Do three drawings in a row all of the same subject.

Spend five minutes on the first one...

Two minutes on the second...

And one minute on the last.

Ignore any unnecessary detail and concentrate on the key components that make up the subject. As you move on to the faster drawings don't rush – just try to distil the drawing down to its most important parts. The last drawing may consist of just a few lines.

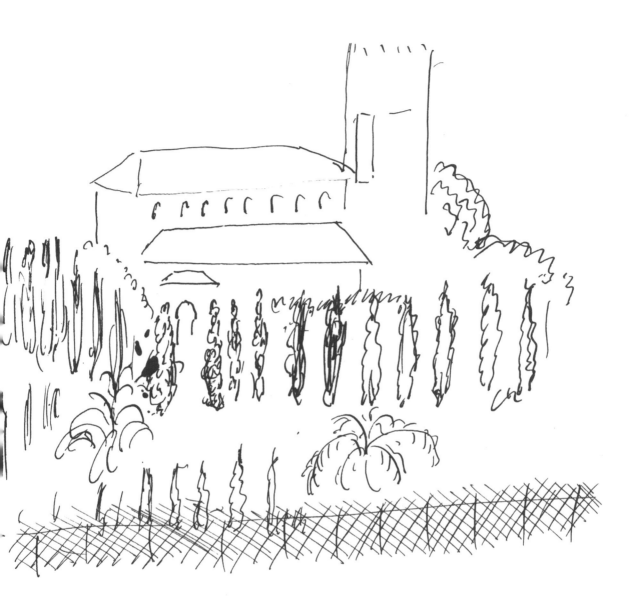

Get a grip

Not all the drawings in this book are made with a pencil. Some are done in ink, some in charcoal, and some even in biro, but when you're starting out all you really need is a humble pencil and a bit of know how. The pencil is going to be your tool for this whole book. It can be used in different ways and to make a variety of marks. To start with, the way you hold your pencil can have a big effect on the mark and line you make.

The standard grip
This is your normal grip, the one you use for writing. Although it varies from person to person, with this grip your fingers are normally close to the tip of the pencil. This allows control over the pressure as well as the direction of the line.

The back-of-the-pencil grip
This creates a looser, sketchy style. It's excellent for roughly sketching the composition at the beginning of a drawing. This grip can also be good for creating broad arcs.

The side grip
With this grip you're almost holding the pencil flat against the paper. This allows the whole edge of the lead to be in contact with the paper. It's perfect for broader marks. This grip is also good for shading since it allows a lot of graphite to be laid down on the paper quickly.

Drawing straight lines

Different grips are useful for different aspects of drawing. The back-of-the-pencil grip is very helpful when drawing straight lines. Holding the pencil some way from the tip, place your hand against the edge of your sketchbook or board. Try resting your little finger against the edge of the sketchbook as well, if you want. Rest the tip of the pencil against the page, then run your hand down the straight edge of the book or board. Remember to keep the pencil still in your hand.

Drawing is a physical activity and you need to think about your position and posture when you are doing it. It sounds obvious, but make sure your arms and hands are free to move and that you're in a comfortable position. If you're drawing from life make sure you are in a position to see your subject and your paper easily. Be prepared to move about a bit.

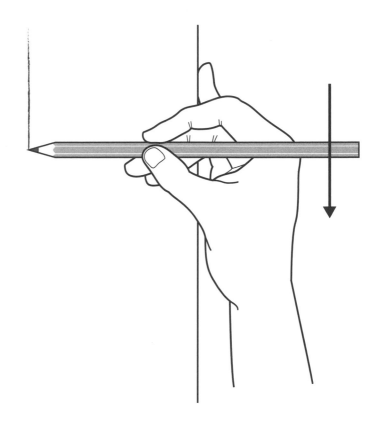

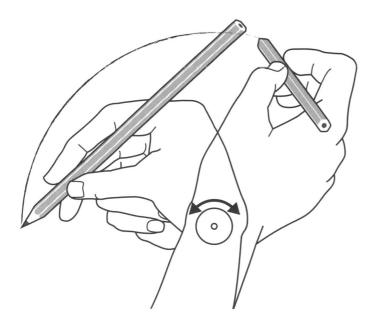

Drawing curved lines

Keeping your hand and arm free to move is especially important when drawing a curved line or an arc. Make sure you have room to move freely. Now think of your hand like a compass, with your wrist as the point. Use the natural arcing motion that your hand wants to move in to create your curved line.

Letting your hand move in a natural way is important when drawing a curved line, but it's equally important to be able to move the paper so as to get your hand in the right position. This is useful when drawing an ellipse, like the top of a mug or glass.

Which is the sketchbook for you?

If you're reading this book you've probably gone out and got yourself a sketchbook, or some nice person has given you one as a present. There's no 'right' or 'wrong' sketchbook, it's just whatever you feel happy with. I prefer to use a spiral-bound book because I find it easier to flip the paper right back on itself. But that's just me.

When it comes to the size of the sketchbook, it's mostly just a matter of common sense. If you want to be drawing outside or when sitting on the bus, a smaller sketchbook is best. A longer, more considered drawing and you may want to use a much bigger pad.

When selecting paper, art shops can confront you with all sorts of different types: various thicknesses and textures, acid free, hot press, cold press... the list goes on. Don't worry about any of that.

Any paper is good for drawing but there are a few things to remember:

Printer paper: Smooth and thin – good for quick sketches (80–120gsm)
Cartridge paper: Has a roughish surface – good for all kinds of drawings (100–200gsm)
Watercolour paper: Usually has a textured surface – robust, good for considered, finished drawings (200–320gsm)

Most sketchbooks contain cartridge paper or watercolour paper. Cartridge paper is good for drawing because it has tooth, which means its surface is slightly rough, letting the graphite stick better. Watercolour paper also has tooth, but is much thicker.

Formats

Standard-size sketchbooks can be used landscape or portrait, but you can also get square ones or long ones, which are good for panoramas. Or just cut your sheet of paper to whatever size you want, and tape it down to a surface to hold it steady.

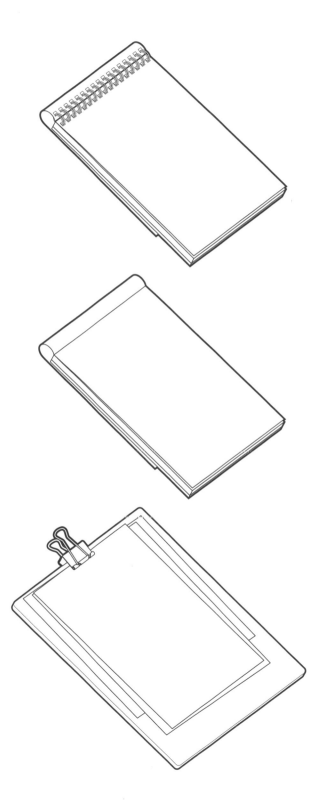

Spiral-bound sketchbook
Normally hardback
 Pros: opens out flat or flips over, so is easy to lean on when standing or on the go.
 Cons: the wire binding means that you can't work across the whole double page.

Perfect sketchbook / stapled sketchbook
Perfect binding is when sections of paper are sewn and then stuck together. Available hard- or softback
 Pros: easier to work across the double page.
 Cons: can be harder to handle when drawing outside. If it doesn't open out flat it can be difficult to work close to the gutter.

Improvised sketchbook
Can be made in a variety of ways. Best to have a hard board to lean on
 Pros: any size, any thickness, any paper you choose.
 Cons: easier to lose drawings.

Draw it in silhouette

Another way of simplifying your subject is by imagining it back-lit, creating a silhouette. This is what William Kentridge did when he produced a series of drawings for the opera *Lulu*. His drawings, done in ink on the pages of a dictionary, were projected during the course of the performance.

This monkey making its way along a branch shows Kentridge's skill at creating clear, convincing form without any detail. He distils the monkey down to simple dark shapes. Instantly we know what it is. Instantly we feel its movement.

Take an object and draw it as a silhouette. Lightly draw the outline first, then just use the edge of your pencil lead rather than the tip to block in a simple area of tone. Then try it without any initial outline.

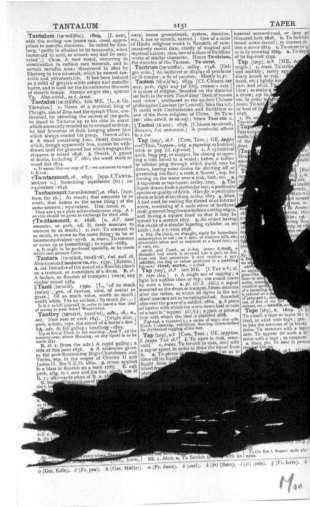

*Untitled Monkey
Silhouette (Talukdar)*
William Kentridge
2013

For another example:
Ellsworth Kelly, p.31

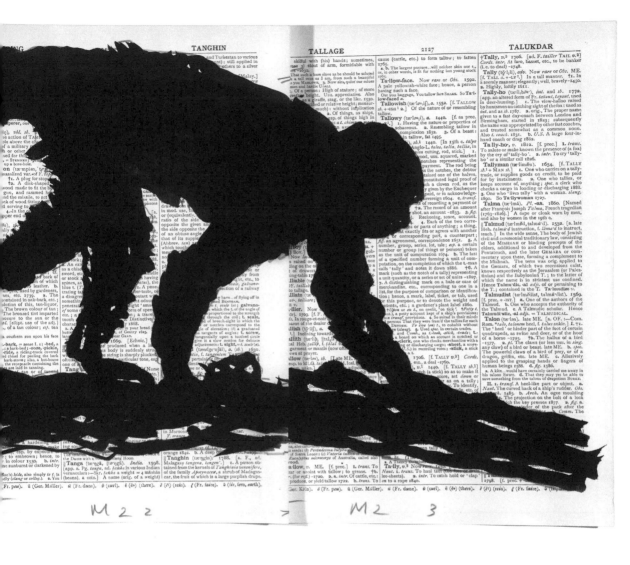

M 2 2 M 2 3

Remember, remember

This is a map of the USA drawn from memory by artist Robert Rauschenberg. Why? Because he was asked to by Hisachika Takahashi, along with 22 other American artists.

As you can imagine what came out of this project were 22 very different drawings, but this wasn't about getting an accurate map of the USA. Takahashi was interested in the artists' perception of their country, and for Rauschenberg it was a cute, boxy country, floating in a sea of white paper. Neat and simple.

Memory is important when drawing, even when the subject is right there in front of you. Every time you look down to your drawing you have to hold the memory of your subject in your mind's eye. This is why the most important thing to get right is how you look at your subject.

Do a drawing from memory, but first spend a minute looking at your subject. It's important here to look rather than just to see. As you look at it, try to imagine that you're drawing it. Let your eye run over it and visualize the lines going down on the paper. Concentrate on the main structure of your subject.

This exercise isn't about doing a perfect drawing. When drawing from memory you won't be able to remember all the detail so you will have to simplify your subject – like Rauschenberg's America. Now turn away and give yourself two minutes to draw it from memory.

Untitled from 'From
Memory Draw a Map of
the United States'
**Robert Rauschenberg and
Hisachika Takahashi**
1971–72

For another example:
Henri Matisse, p.19

Let there be lines

No need for memorizing here. Giacometti would hardly have taken his eyes off these apples. I can imagine his hand a blur of movement as the swirling lines flew around each other, creating the shapes and form of the fruit in front of him.

Alberto Giacometti was a Swiss artist, acclaimed for his thin, heavily worked sculptures of figures. His drawings, like his sculptures, feel like they drill down to the core of a subject with incessant working and reworking.

Finding the right line isn't easy and sometimes it's necessary to put lots of lines down while searching for the right one. This isn't a bad thing, and you don't have to reach for the eraser every time. Shapes can emerge from the chaos of frenetic lines. This may seem haphazard, but this type of drawing is just as accurate as a clean, single-line drawing.

When drawing in this style keep the pencil moving quickly. As always, remember to look at your subject more than your drawing. The drawing will gradually emerge, so be patient and allow the correct shapes to form as you go. As they start to emerge, press slightly harder to make the lines darker and bolder.

Three Apples
Alberto Giacometti
1949

For another example:
Henry Moore, p.48

Don't look down

No background, no context – these apples are just crisp outlines and empty space. The style of this sharp, precise drawing is in total contrast to Giacometti's swirling busy apples, like walking from a busy Victorian curiosity shop into a white-walled modernist gallery.

The lines in Kelly's drawing plot every wobble and nuance of each apple. He makes no assumptions as to what an apple looks like – none of 'here's a circle with a little stalk on top'. This is about actually seeing the shape of the object that's in front of you. Whether an apple, a tree or a novelty lollipop, the most important thing is to really see it.

Do a drawing only looking at your subject, not at your paper. Remember that it doesn't matter what it ends up looking like – this is about tuning your eye into really seeing what's in front of you. It's like you're a highly sensitive drawing machine, your eye zoomed right in on every quiver of the outline, your hand super sensitive as you feel your way around the object.

Apples
Ellsworth Kelly
1949

For another example:
Boris Schmitz, p.15

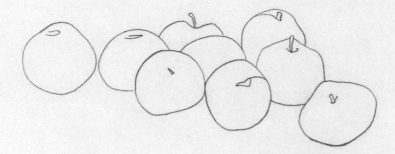

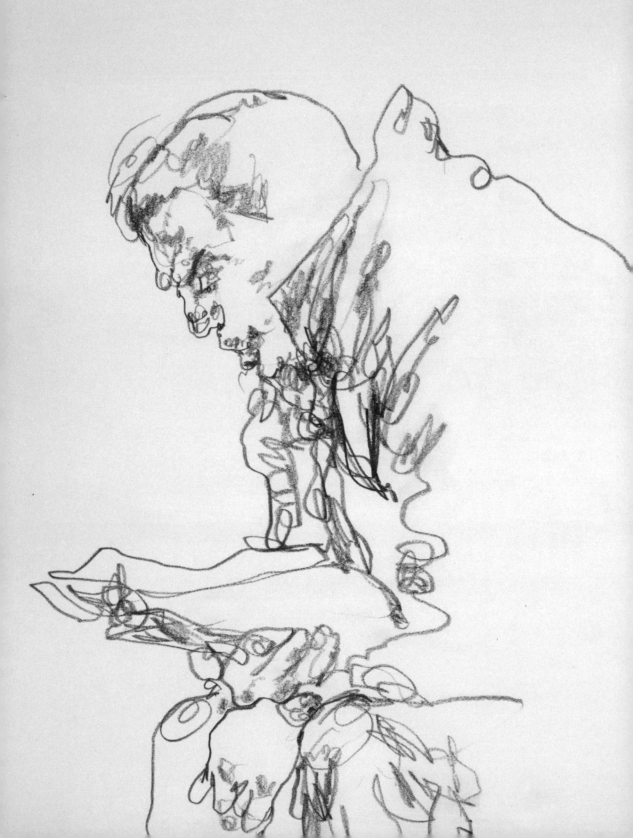

Everyone's a model

Gregory Muenzen sketches his fellow New Yorkers as they go about their daily lives. Like a candid photographer he works quickly and his subjects remain totally unaware of their role as artist's model.

Like with Giacometti's drawing this picture emerges from an energy of mark making. Muenzen varies the pressure of the lines and marks, building up to create a dynamic drawing. This quick style of drawing gives an impression of the subject rather than an exact description of it.

Despite working quickly, every line helps describe the figure, from the single nuanced line that outlines the jacket on his back, to the swirls and squiggles down the creases of the arms. Although Muenzen's drawing has a loose, flowing quality, it's still sharply observed.

The great thing about drawing is that you have potential subjects everywhere. People, especially, will move, but if they do, just start another sketch. Remember to relax. Work quickly and don't worry about having to finish these drawings. Always look more at your subject than at your paper and keep your hand moving. If you get stuck just move on.

Passenger Reading a Newspaper on a Rush Hour Broadway Local Subway Train
Gregory Muenzen
2012

For other examples:
Boris Schmitz, p.15
Alberto Giacometti, p.29
Quentin Blake, p.109

SEPTVAGINTA DVARVM BASIVM SOLIDVM.

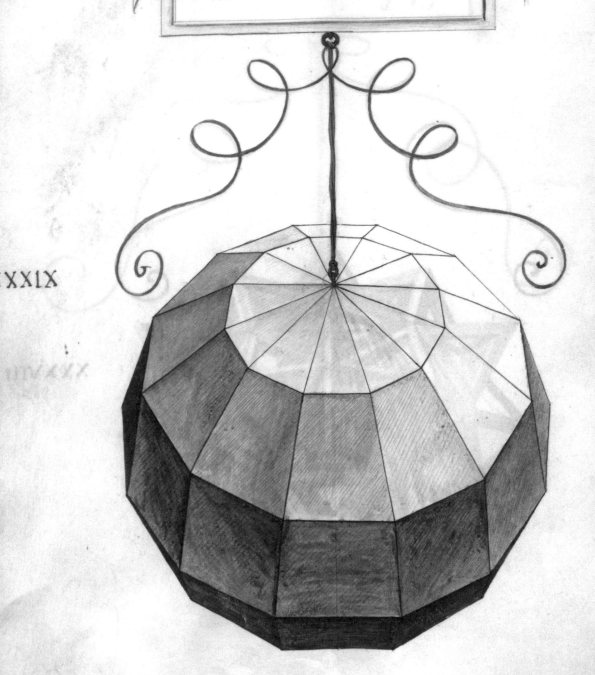

Ἐβδομήκοντα δύο βάσεων ζου.

Tone

THE SCIENCE OF THE SOLID

A tonal drawing isn't just an outline, it has areas of light and dark. Adding tone to a drawing is called shading and this can totally change its appearance.

Leonardo da Vinci made a science of drawing. This sphere is part of a series of drawings he made to illustrate Luca Pacioli's book *De divina proportione*. Despite being a theoretical shape, Leonardo achieves a realistic sense of three dimensions by shading it, creating areas of dark, mid-tone and light. Each facet of this shape is shaded, from black to white in an ordered gradation, creating a sense of solidity and form.

There are many different shading techniques, all helping to produce a range of dark tones to give the effect of shadow on a surface. Each example in this section will look at one technique in isolation, but in reality you don't ever have to use just one. Often a great tonal drawing is a combination of different techniques.

You can practise all of these by drawing an apple. It's a simple place to start, and when you have got the feel of shading your apple, you'll be ready to try something else.

Solid Campanus sphere,
from *De divina proportione*
Leonardo da Vinci
c. 1509

Drawing tools

Pencil – very important

You can draw with anything. Anything that makes a mark on a surface. Biro, lump of coal, quill and ink, whatever takes your fancy. But the easiest, certainly the most easily available, medium to use is a pencil. In this book every drawing or technique you try can be done with nothing more than a pencil.

Eraser

An essential tool because we all make mistakes. An eraser removes pencil or charcoal from the paper. Good for getting rid of wayward lines but also excellent for creating highlights. Using a scalpel or stanley knife, you can carve an eraser to a sharp point, which will give you more control when you use it.

Fixative

Fixative prevents pencil marks from smudging and rubbing off the paper. It also works for charcoal and chalks as well as anything dusty or crumbly, literally sticking them to the surface of the paper.

You can buy proper fixative or you can use hairspray as a cheaper option. There is very little difference – the active ingredient is acrylate. Make sure that you do it in a well-ventilated room or outside because it's not nice stuff to breathe in.

Blending tool
The most obvious blending tool you can use is your finger (I just haven't put a picture of that in here).

 The others are a cotton bud (q-tip) and the slightly esoteric tortillon, or drawing stump. The latter is a tightly rolled paper that tapers to a point.

Scalpel or stanley knife
A scalpel or stanley knife can be used to sharpen your pencil. As you just sharpen the nib of the pencil, you don't waste as much pencil. And you also don't get the same amount of shavings.

 A scalpel is also useful to cut and shape your eraser, allowing you to rub out more accurately.

Traditional pencil sharpener
A traditional pencil sharpener is a good and safe tool. But you will go through your pencil pretty quickly in keeping it sharp, and have lots of shavings.

Sharpening pencils

Keeping your pencil sharp is very important and how you sharpen your pencil can affect the sort of mark it makes.

A traditional pencil sharpener will give you a uniform, smooth, rounded surface to the pencil lead. This can be more effective if you're shading using the side grip.

A scalpel or stanley knife gives a finer, sharper point which will give you more incisive marks. But be careful when doing this, and make sure you always cut away from your body.

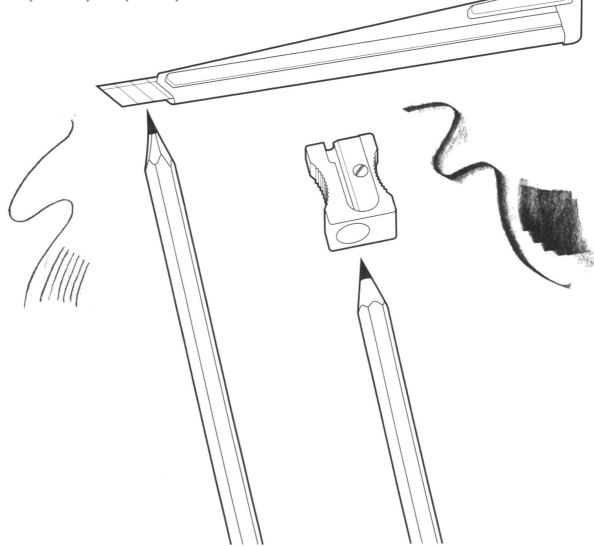

Pencil varieties

Pencils come in a range from 9H to 9B. The Hs are hard, with 9H being the hardest. H pencils will stay sharp longer and leave a much lighter mark. B is for black, and these pencils are softer, so leave a lot more graphite behind. They get blunt faster, but produce much darker marks. HB is bang in the middle, neither hard nor soft.

Light ⟶ **Dark**

9H	8H	7H	6H	5H	4H	3H	2H	H	HB	B	2B	3B	4B	5B	6B	7B	8B	9B

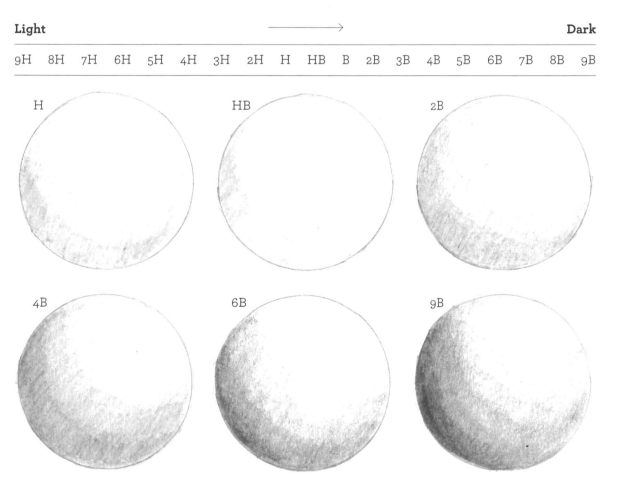

For the drawing exercises in this book and general sketching, the range from B to 6B is all you'll need. I prefer to draw with a 2B as it gives a good dark mark when needed, but it's still possible to work lightly, and it doesn't go blunt too quickly. The difference between some of the grades can be subtle, and different brands can vary slightly.

To Cecil from
Lucian Freud
24 . 8 . 48

Apple
Lucian Freud
1946

For other examples:
Matthew Carr, p.73
John Singer Sargent, p.91

Don't be afraid of the darks

Leonardo's drawing at the start of this section was of an imagined object. Lucian Freud's gnarly, wrinkled apple, however, is very real. It sits on a solid surface and casts a definite shadow. The shading here doesn't step down in neat graduated facets but curves around the surface of the apple, changing from light to dark very quickly. The creases and folds are accentuated by these intense darks and lights.

To create this effect, Freud used a single strong light source. The stronger the light source, the darker and more pronounced the shadows. This distinct contrast between light and dark creates a more vivid dramatic drawing, while the tone creates a more tactile sense of solidity.

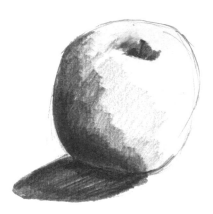

Place your apple under a lamp. See how contrasty it has become? Using a 4B, shade from dark to light.

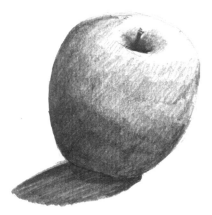

Apply the most pressure in the darkest areas and ease off as you move up to the light. See the difference a softer pencil makes?

Look for the shapes

Emil Bisttram's self-portrait stares back at us, his face, like chiselled stone, is made up of clearly defined shapes of light and dark. The light source comes in from the left of the drawing and serves to emphasize the sharp, angular surfaces that make up his face, like a more irregular version of Leonardo's sphere.

A face is a whole load of bumps and lumps that catch the light, creating patches of light and dark. Bisttram builds the structure of his face with a series of abstract shapes that, if dismantled, would just be a triangle of black, a rectangle of dark grey and so on, but together become a coherent whole.

To find these shapes, squint at your subject so your eyes naturally remove the finer details. This way you'll begin to see things as patches of light and dark.

Self-Portrait
Emil Bisttram
1927

For another example:
Matthew Carr, p.73

Give this a go with your apple, breaking it down into patches of light and dark.

First, draw the basic shape of your apple.

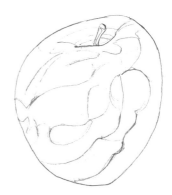

Then start mapping out the different areas of light and shade.

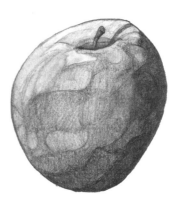

Start shading these areas in and add more lines at the end to refine the image.

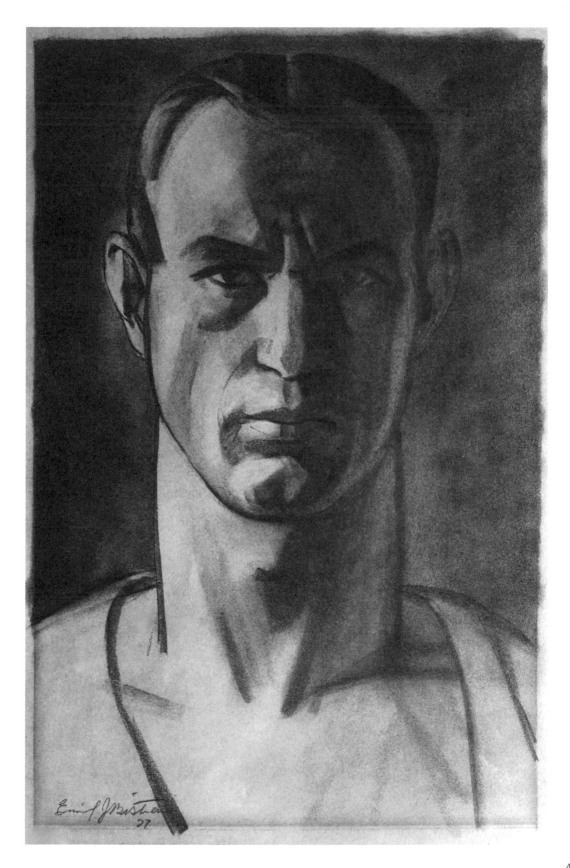

43

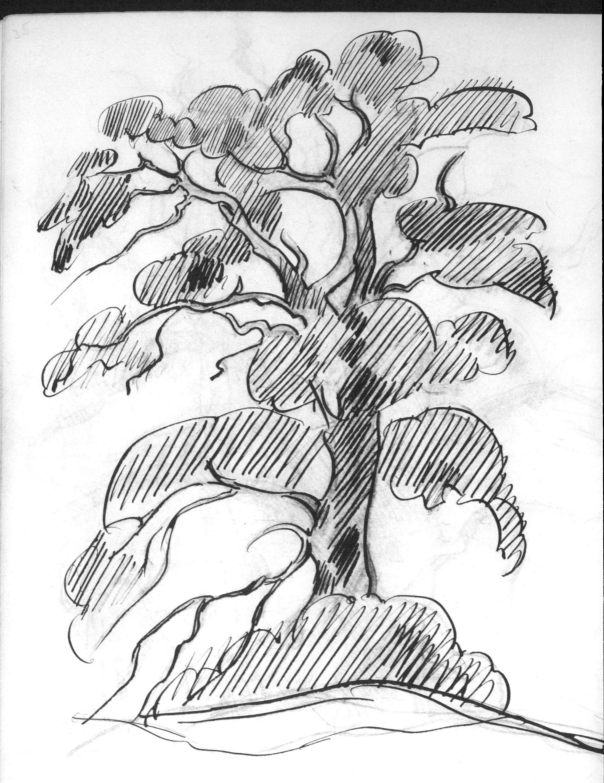

H. Gaudier-Brzeska

Fill it up

Henri Gaudier-Brzeska sums up this lone tree using swift, insightful strokes to form the outlines, and then adds sharp diagonal hatching to give a fluid sense of form.

Hatching is a satisfying and quick way of creating large areas of tone. But working quickly doesn't mean scruffy or slapdash. The marks in Brzeska's tree may be quick, but they're also precise. He creates depth by applying more pressure to some areas of hatching and by bringing the lines closer together.

Apply this method to your apple.

First draw its outline. Come on, be fluid like Brzeska! Now cover the majority of the surface with broad diagonal strokes.

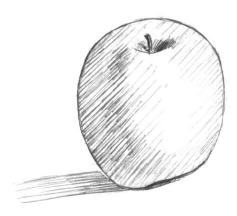

Finally, add some closer, heavier marks to represent the darker tones. Don't forget to vary the pressure of the mark.

Tree on the Crest of a Hill
Henri Gaudier-Brzeska
1912

For another example:
Pam Smy, p.61

Get cross (-hatching)

In Robert Crumb's portrait of the cult Beat writer Jack Kerouac, he uses 'cross-hatching' as well as hatching. This creates a much broader range of tones than simple hatching, and allows for a slightly more complex representation of form and shape.

Cross-hatching is simple in theory but it can be much more sophisticated in practice. The darker tones come from building up the layers of graphite in a criss-cross of marks, as well as varying the pressure of the mark. The more layers you add, the darker the tone gets. And you can vary the direction of these marks to further describe your subject's form.

Take your apple and start as you did with the previous exercise.

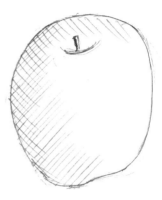

Note how Crumb covers the whole subject with tone. The only bits left untouched are the highlights on the face. Now create cross-hatching with lines that run in the opposite direction.

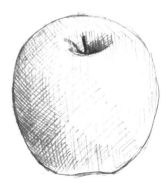

Keep building up the lines where the shadows are darkest.

Portrait of Jack Kerouac
Robert Crumb
1985

For another example:
Matt Bollinger, p.110

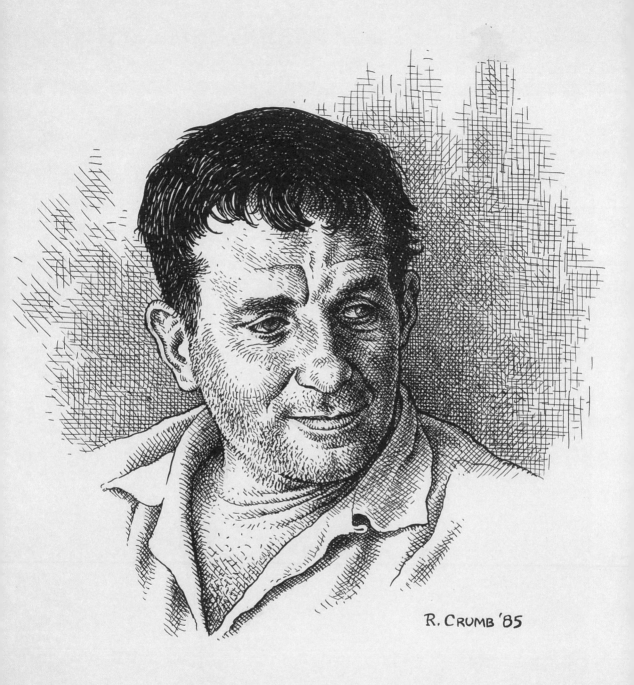

R. CRUMB '85

Simple cell-like backgrounds
Shelter drawings — Move positions of hands + arms + faces.
Remember figures last Wednesday night (Piccadilly Tube)
Two sleeping figures (seen from above) cream coloured
thin blanket. (drapery closely stuck to form)
Hands & arms — Try posit was one self.

Two figures sharing same green blanket

Wrap it in a line

Henry Moore loved form and structure in his drawings and sculptures. The lines Moore uses to describe the two figures here wrap around the bodies, forming and shaping them like one of his curvaceous stone sculptures. These flowing lines accentuate the rounded forms of his subject.

Contour shading helps to describe the curves of your subject, and you can create tonal range by building up the layers in the same way that you can when cross-hatching.

When applying this to your apple, think about how the curves run vertically as well as horizontally. Each line helps to describe the rounded shape.

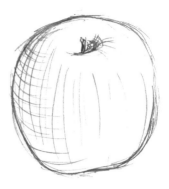

Draw the basic shape and then start working the lines around it.

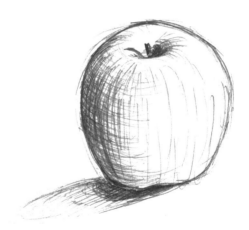

Keep at it until you feel you have completely moulded your image.

Two Figures Sharing the Same Green Blanket
Henry Moore
1940

For another example:
Alberto Giacometti, p.29

Go dotty

Miguel Endara makes this playful drawing seem so solid you would never guess that it was made up entirely of dots. But that's exactly what it is – from the dark areas made up of densely packed dots to the sprinkling of dots that create the lighter areas.

Unlike hatching, which can be quick and incisive, 'stippling' is a technique that requires patience, but it's worth it. The darker areas are made by grouping the dots closer together, while the lighter areas appear where they're more spread out. The size of the dot also has an effect on the intensity of the tone: bigger dots will be darker, smaller dots will be lighter.

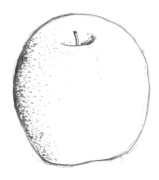

Take your apple and give yourself some time for this one. Start in the darkest area, working the dots tightly together. Then as you move across the lighter area, begin to space them out more.

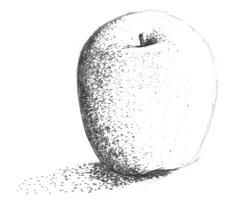

You can always come back to the darker areas and intensify them later.

Wake Me
Miguel Endara
2007

For other examples:
John Singer Sargent, p.91
Vincent van Gogh, p.103

Make it smooth and seductive

Odilon Redon's sensuous depiction of two pears is made all the more enticing by the creamy roundness of the fruit. Their soft, smooth shading lends the whole scene a dreamlike tactility.

Blending or rubbing graphite on the page will produce a smooth gradation from dark to light without the more 'scratchy' marks of hatching. Use a really soft pencil for this because that will lay down the most graphite on the page.

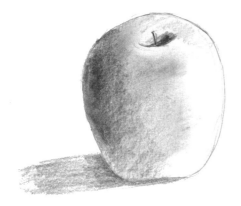

Draw the outline of your apple. Then begin to shade, just like you did for the example on p.41. Now, with your finger, carefully begin to rub the shaded areas, smoothing away any marks and allowing the graphite to blend from dark to light.

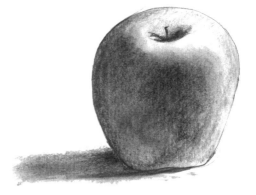

The graphite will smudge over the outline of your apple, but don't worry. You can use your eraser to clean that up at the end.

Two Pears
Odilon Redon
late 19th century

For other examples:
Paul Noble, p.95
Alan Reid, p.117

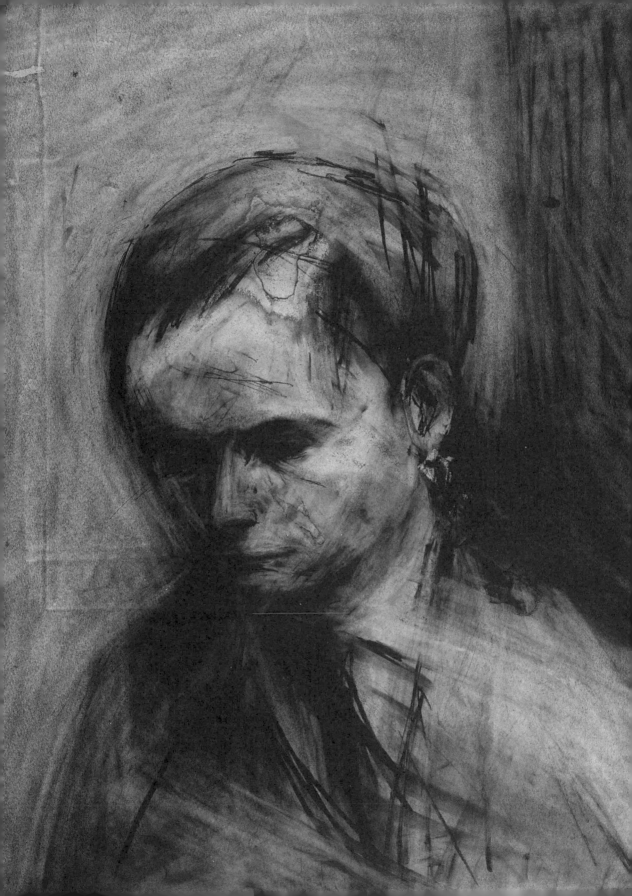

Start in the dark

Frank Auerbach would often tear his paper and then have to patch it up. As with this portrait of fellow artist Leon Kossoff, he constantly rubbed off then reapplied charcoal, almost like he was carving the figure from the surface of the paper.

An eraser isn't only for getting rid of mistakes. It can be used to create the image. If you put down a large area of dark tone across the page first, you can then rub back with the eraser to create the patches of light that allow the form to emerge. It's the same as shading, but in reverse.

And it's not just about form. Working from dark to light can also create dramatic, moody effects, as with Sue Bryan's *Edgeland V* on page 57. There the brambles emerge from the page, but their outlines come from being silhouetted against the pale, luminescent sky.

Try drawing an apple this way. Cover your page with graphite. It doesn't have to be totally black, just a good solid grey.

Now look at the apple modelling for you. Look especially for those shapes of light and dark. With your eraser, start at the lightest area and rub back to the white paper. Clean the graphite off your eraser frequently by rubbing it on another surface.

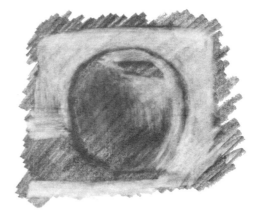

Then rub back to the greys. If your eraser is getting worn down, you can use a blade to cut and shape it.

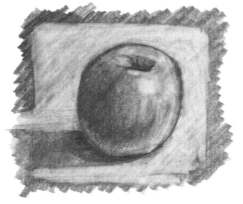

Now go back over the image with your pencil and refine the detail.

Portrait of Leon Kossoff
Frank Auerbach
1957

For another example:
Sue Bryan, p.57

Be dark and moody

Sue Bryan's evocative *Edgeland V* is part of a series of drawings that describe the mysterious atmosphere of overlooked spaces, bringing to our attention the beauty of these coarse scrublands silhouetted against a grey, luminescent sky.

Tone doesn't just create solid three-dimensional forms, it can also create strikingly atmospheric effects. In Bryan's drawing the texture of the brambles and bushes is created by subtle smudges of light and dark, with no need for outlines to define them.

Try creating your own atmospheric landscape by smudging and rubbing back into a drawing.

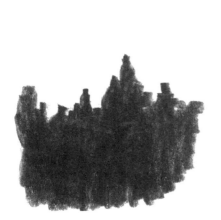

Using a 6B pencil, block in a dark area of tone, but make ragged triangles at the top, like treetops.

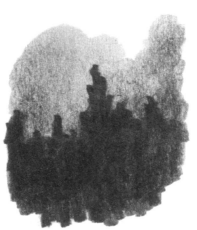

With a circular motion, bring in a lighter tone above for the sky.

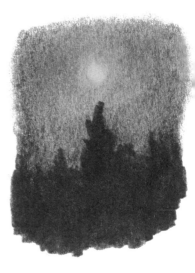

You can use your eraser to rub back and create a lighter 'glow'.

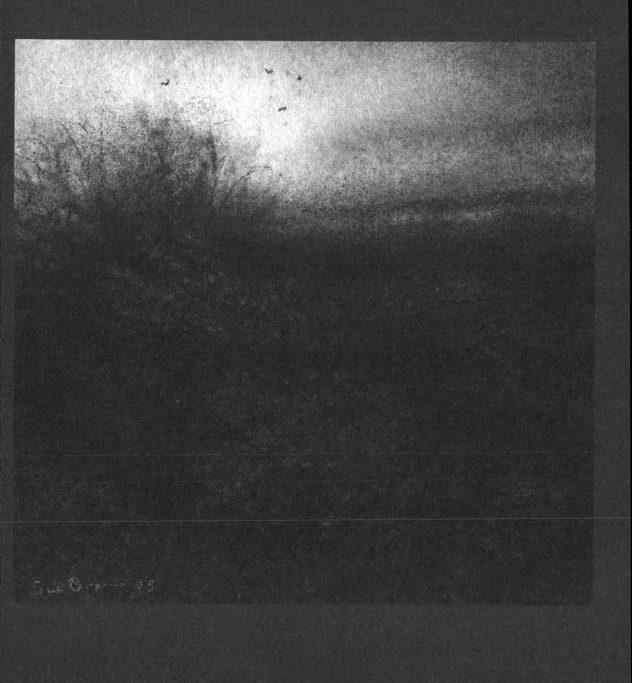

Edgeland V
Sue Bryan
2015

For another example:
Frank Auerbach, p.54

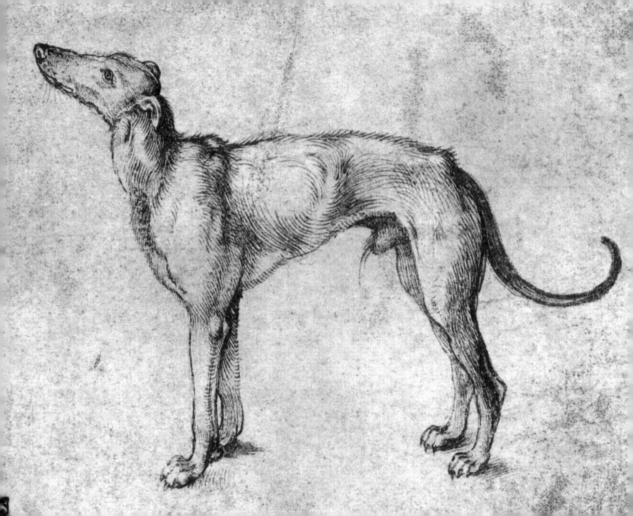

Accuracy

KEEP IT REAL

You see and experience the world around you and want to get it down on paper. But you want to get it down on paper in a way that looks 'real', or at least feel like you're in control of how the drawing looks. Albrecht Dürer's drawing of a greyhound reveals just how controlled and real a drawing can be.

The exercises until now have hopefully loosened you up and got you looking at things more closely. Now we're going to look at some techniques to improve your accuracy.

Many of these techniques are designed to help you keep things in proportion. This is one of the fundamental aspects of drawing accurately. All of these techniques are transferable. By that I mean that they can be applied to a variety of subjects. The way we draw a figure accurately is no different from the way we would tackle a building, a tree or anything else. It takes a bit of time to master, though, because to draw accurately you must be patient.

A Greyhound
Albrecht Dürer
c. 1500

Plan it, draw it

Pam Smy's soft, rhythmical drawings enhance the pages of many books, and these drawings are for *The Ransom of Dond*, a story about a young girl facing a terrifying destiny. These two pages, taken from Smy's sketchbook provide a brilliant insight into the process of building a drawing.

Not all drawings need to be like the swift, spontaneous sketches of Gregory Muenzen on page 32. Here we can see how Smy works out the structure of the figures in the boat before fleshing them out. You don't have to get everything right straight away, because drawing accurately can be a slow process.

No matter how good you are at drawing, or how long you've been doing it, a finished, polished drawing doesn't just magically appear. It's a process. In this process, work lightly to begin with, so if you make a mistake it's a lot easier to rub out. It's not necessary to use an H pencil for this, just don't press too hard with the one you're using. When everything is in position, then you can go back over the drawing to firm up your lines.

Carrying a sketchbook means you can create doodles and quick sketches whenever you feel like it, but it will also provide you with a great source of ideas for other drawings.

Sketchbook pages
Pam Smy
2013

For other examples:
William Kentridge, p.25
Henri Gaudier-Brzeska, p.44

I can't draw upside down girls 21/4/13.

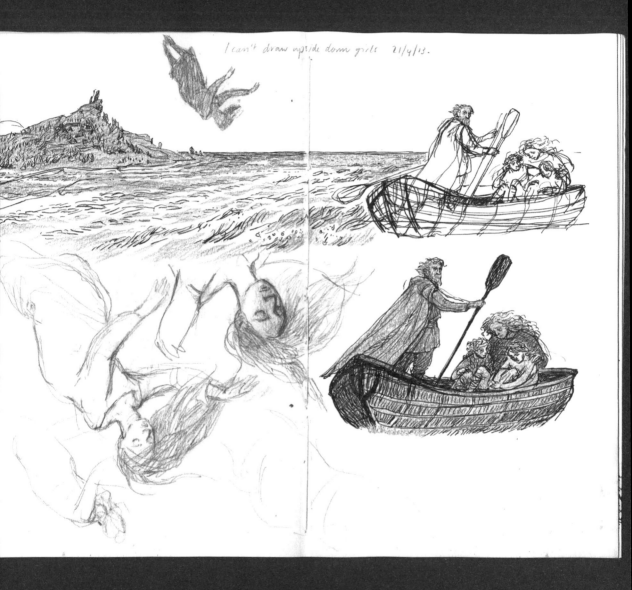

Find your angle

Egon Schiele's angular style is more often associated with raw, sexually charged figure drawings, but here his incisive lines make perfect sense of this angular tangle of roofs and gables.

It's not always easy to see the scene in front of you clearly. Sometimes we need some help to figure things out. Looking closely is a start, but sometimes our eyes can play tricks on us. To create this accurate drawing, Schiele had to make sure he got all the angles correct. One really useful method of checking your angles is to use your pencil as a straight edge.

Practise doing this by looking at the corner of a table. Hold your pencil out in front of you so that it makes a horizontal line. Now close one eye and line the pencil up with the edge of the table. Look at the angle of your pencil. This will give you a pretty good idea of how steep or shallow that line of the table is. This method works with vertical lines as well. This won't give you an exact measurement, but it will give you a useful indicator.

To gauge the angles of the rooftops, Schiele would have used his pencil as a visual guide.

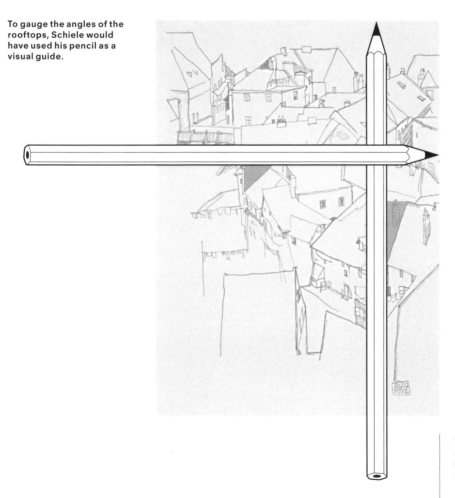

Crescent of Houses in Krumau
Egon Schiele
1914

For another example:
Jim Dine, p.77

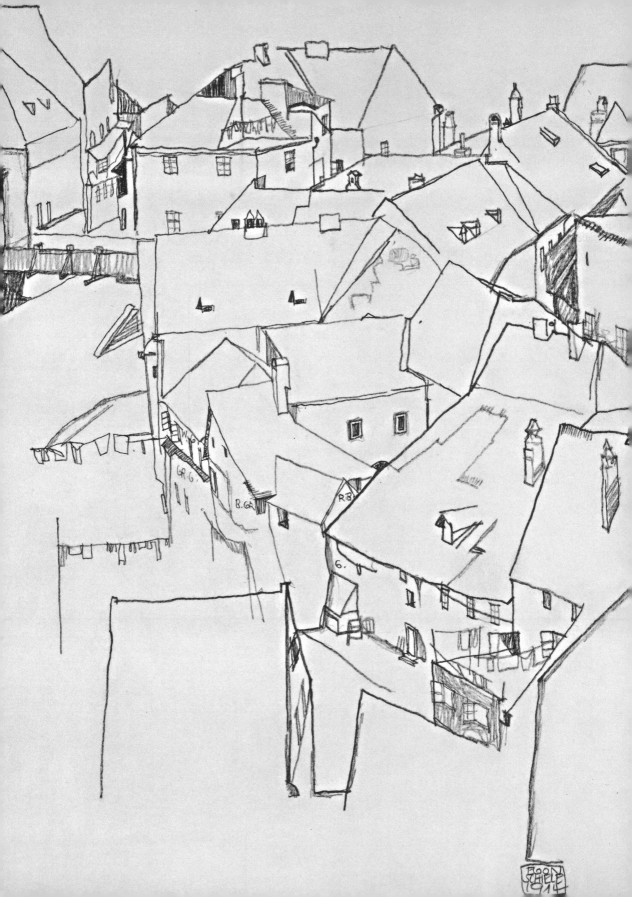

Use a measured approach

When trying to draw accurately, one of the most important things to do is get the proportions correct. To do this you simply have to compare the size of one part of an object to another.

Sabin Howard creates incredibly lifelike sculptures and it all starts by getting the basic proportions right in initial drawings. Here Howard simplifies the head, the hips, the torso and the limbs in order to focus on the proportions. With lines clearly marking the top and bottom of the head, Howard can count off how many times it will fit inside the rest of the body, and then size the other elements accordingly.

General rules of thumb for the human figure:
- The head fits seven-and-a-half times into the human body.
- The distance from the top of the skull to the bottom of the hip is equal to the distance from the hips to the floor.
- A person's span from fingertip to fingertip is the same as a person's height.

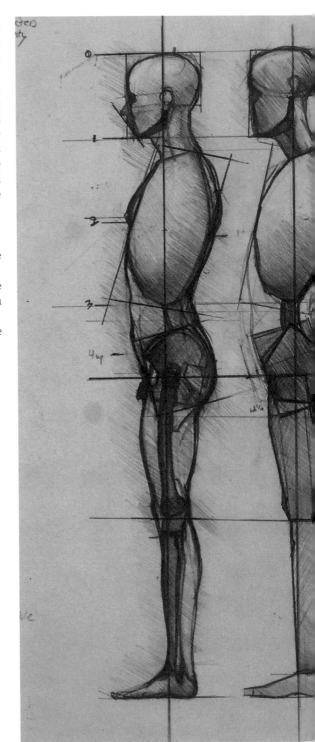

Anatomical Study
Sabin Howard
1992

For another example:
Howard Head, p.69

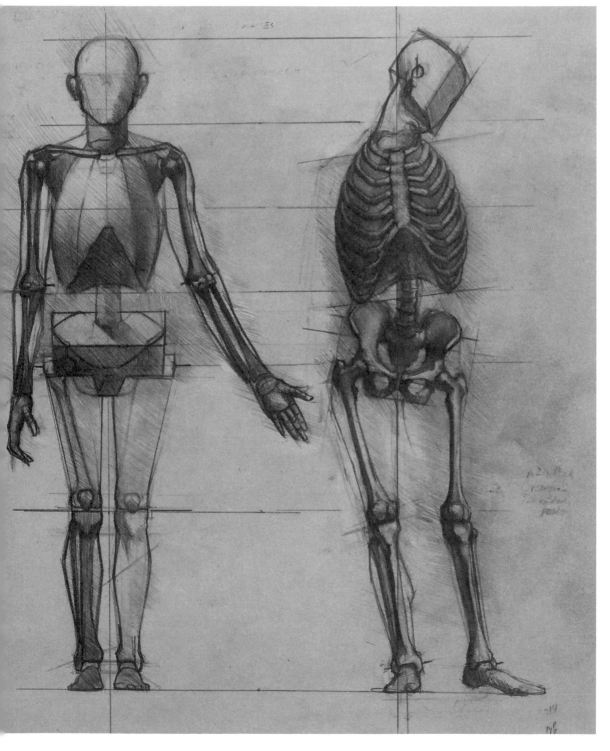

Keep things in proportion

The measuring technique described on the previous page isn't limited to the human figure. To discover how you can use it to identify the correct proportions of any object, go out and find a tree. Use the trunk as your starting point and measure its length by holding your pencil out in front of you. Now count how many times that fits into the body of the foliage.

Mark those spans down on your page with light guidelines. Do the same for the width of the tree. Now you have a very accurate representation of the tree's proportions. All that remains is to add some detail!

Hold your arm out straight
When using your pencil to measure it's important to keep your arm out straight. This means that you keep a standard distance between your eye and the pencil. If you don't do this all the sizes will appear different each time you come to measure.

First hold the pencil vertically
Close one eye and position the tip of your pencil against the top of the tree. Now slide your thumb down the pencil to the bottom of the trunk.

Then hold the pencil horizontally
Holding your thumb in the same position, flip your hand around so that your pencil is horizontal. Starting from the far edge of the tree, count how many times the length of the trunk fits into the width.

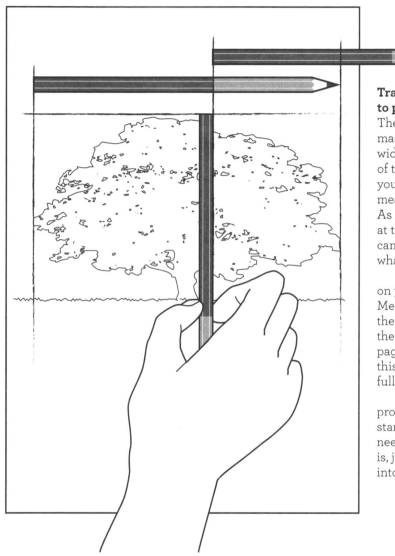

Transfer the measurements to paper

The measurements you have just made are to establish a ratio (the width of the tree is equal to x number of trunks). Establishing a ratio means you don't have to stick to the original measurement of the trunk you made. As long as the tree width remains at the same ratio to the trunk, you can draw the trunk on the page at whatever size you choose.

Establish the height of the tree on your page with a simple line. Measure that out on your pencil and then count out the number of times the height fits into the width, on the page. Mark those two edges off and this will give a box. That box is the full extent of your tree.

Once you have the correct proportions in place you can then start to draw in the foliage. If you need to work out how big the trunk is, just count how many times it fits into the total height.

Engineer your drawing

Every great product starts with a drawing. A drawing communicates clearly and precisely what it will look like. Carefully marked out and executed, with the guidelines still visible, this drawing shows the shape and structure of a tennis racket yet to be made.

Howard Head, frustrated with how poor his tennis was, decided to sort out his equipment as well as his forehand. His training as an aeronautical engineer is evident in the marks that plot out an accurate path for the line to follow.

You don't have to launch straight into a drawing with all lines blazing. Instead, it can be helpful to mark out where lines are going to go with a simple cross, or to run a light guideline across the page to help with the position or angle of other lines.

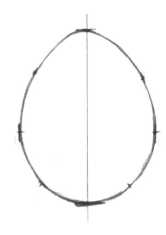

Draw an egg. Start with a centre line, then mark the top and bottom of your egg. Make a mark near the top and near the bottom of your line.

Next mark the sides, working out the proportions as demonstrated in the previous exercise. Make sure that the distance between marks and the centre line are equal, to ensure your drawing is symmetrical.

You can make as many marks as you want. These will provide a guide for your line to follow.

Design for oversized tennis racket
Howard Head
1974

For other examples:
Sabin Howard, p.65
Hokusai, p.75

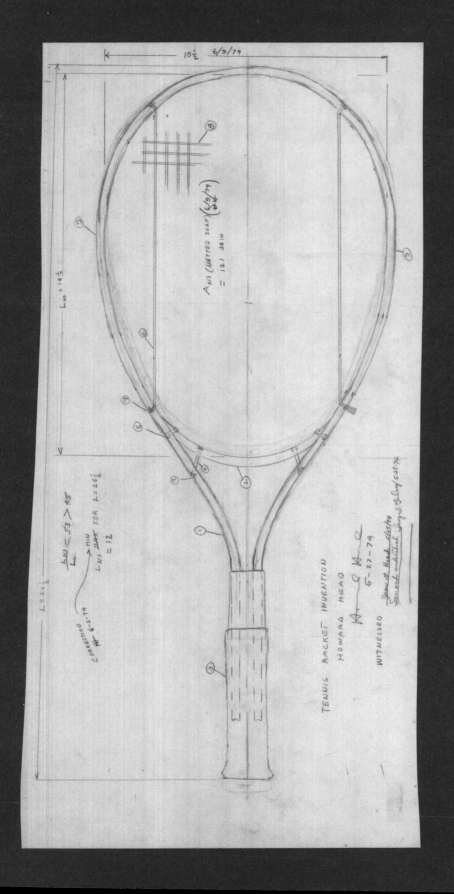

TENNIS RACKET INVENTION

HOWARD HEAD

6-27-74

Puzzle it out

When trying to get down a scene that's in front of you accurately on paper it's difficult to know where to start. It's like a puzzle and you have to get the pieces in the right place to make it look right. The first thing to do is work out what your main focus is going to be and take a moment to visualize how your drawing will look on the page.

Roughly work out the scale of your subject. Make sure it fits on your paper. Work lightly because most of these marks will be rubbed out. Make sure you get the basic proportions right.

Use your pencil to work out some of the angles. This is still early stages, so things will change.

Now you can start to puzzle out the spatial relationship between the various objects in your drawing. Use your pencil as a horizontal or vertical line to check where things are in relation to each other.

Once you're happy that the underlying structure of your drawing is correct you can bring in the details and refine it, eventually erasing any guidelines and rough markings.

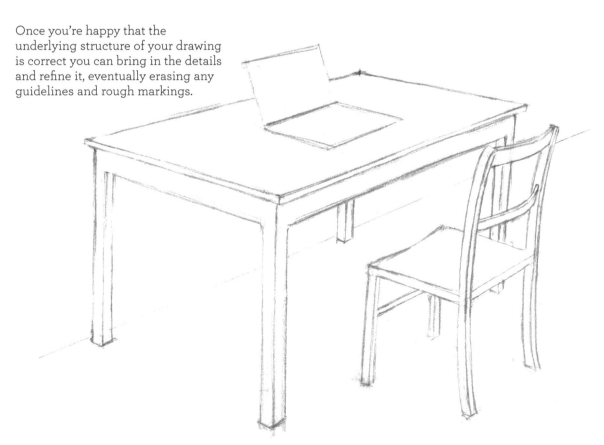

Face facts

Isolated on the page like this, Matthew Carr's portrait has heightened intensity as it stares back at us. The human face is incredible, and Carr's drawing demonstrates this with unadorned simplicity. Before building up the subtle layers of tone and the details of the features, Carr would've had to make sure that the overall structure of the face was correct.

We are all individual. Our features and the shape of our heads are unique. There are, however, some underlying facts about how everyone's face is put together and it's quite handy to know these basic proportions. These guidelines won't beat the fundamental act of looking, but they will help you to avoid some basic errors.

Try this yourself by doing a self-portrait. Here are the guidelines to basic face proportions.

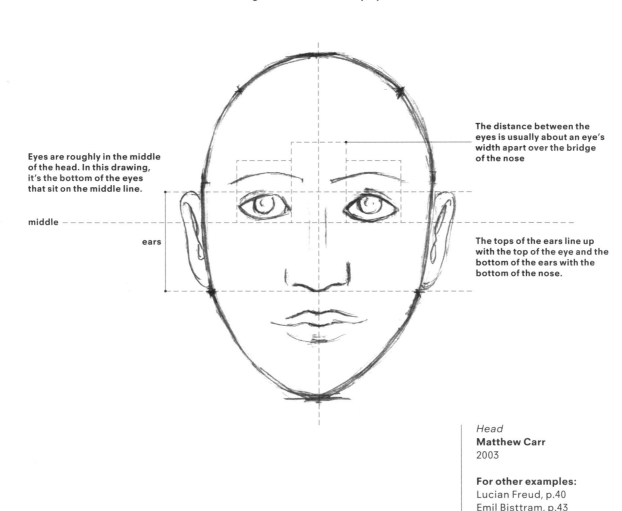

The distance between the eyes is usually about an eye's width apart over the bridge of the nose

Eyes are roughly in the middle of the head. In this drawing, it's the bottom of the eyes that sit on the middle line.

middle

ears

The tops of the ears line up with the top of the eye and the bottom of the ears with the bottom of the nose.

Head
Matthew Carr
2003

For other examples:
Lucian Freud, p.40
Emil Bisttram, p.43

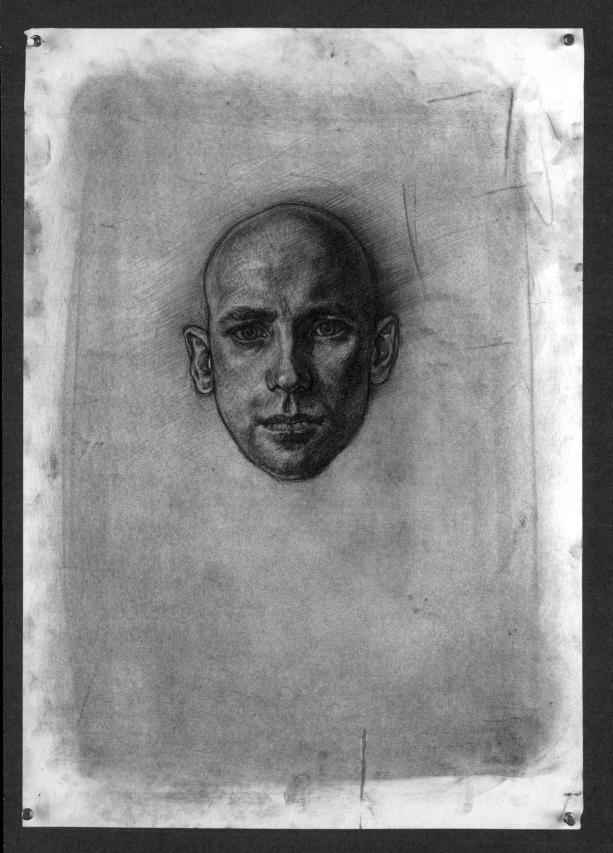

73

Shape the things to come

When you look past the complex you can see the simple 'building blocks' that lay underneath. On the right-hand side of this drawing by Japanese artist Hokusai we see a cute squirrel nibbling on a vine, bushy tail hanging down and ears pricked up. The left of the drawing shows how Hokusai started his image by breaking the subject down into shapes.

Hokusai produced hundreds of woodblock prints, his most famous depicting views of Mount Fuji. Something they all have in common is an elegance that comes from a strong, simple underpinning structure. Breaking complex subjects into circles, squares, rectangles and triangles will look odd at first, but once you have the geometric structure you can build the details on top.

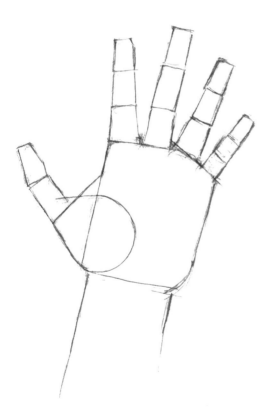

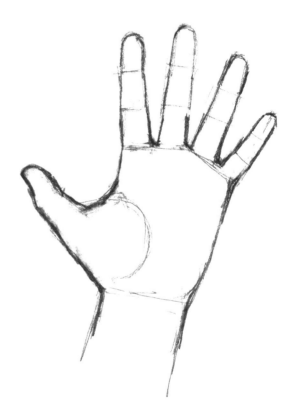

Take a subject close to hand, like your hand! Don't think about it as one shape. Instead, mentally dismantle your hand into circles, rectangles and triangles, and then get these down on paper.

Then start moulding the shapes together with your pencil.

Studies of Animals
Hokusai
1812–14

For other examples:
Emil Bisttram, p.43
Jim Dine, p.77

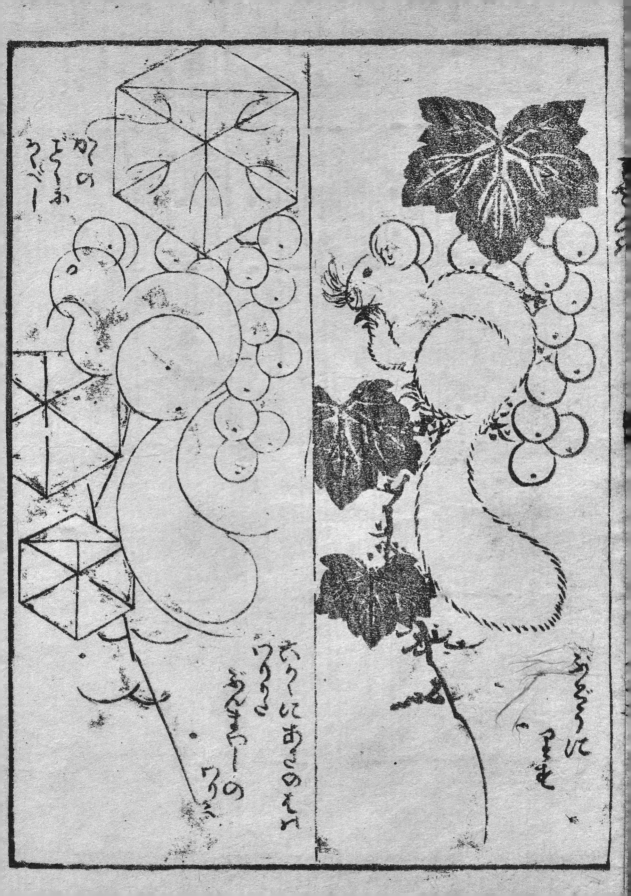

Accentuate the negative

Jim Dine's wrench emerges from the page like a prehistoric fossil in a craggy rock face. It's amazing how something so humble can become so powerful. Transforming the everyday into something special is what Jim Dine did in a series of works in the 1970s, depicting items ranging from paint brushes to hammers.

The area around an object is called negative space. Here Dine makes the negative space more apparent by shading. When drawing, looking at these gaps can help you get a clearer picture of the shape and form of your subject. This goes for anything you choose.

Begin by choosing a single object to focus on.

Again, you can use your pencil as a handy tool to help you with this exercise. Hold it out and make an imaginary line between points on the exterior of the object.

Now apply shading to the areas around the scissors. Note how this brings your object into sharper relief.

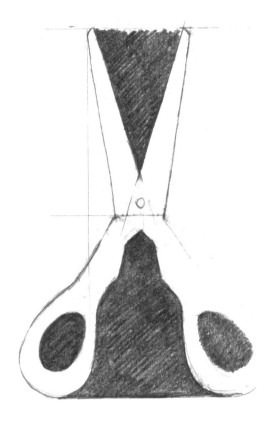

Untitled
Jim Dine
1973

For other examples:
Egon Schiele, p.63
Hokusai, p.75

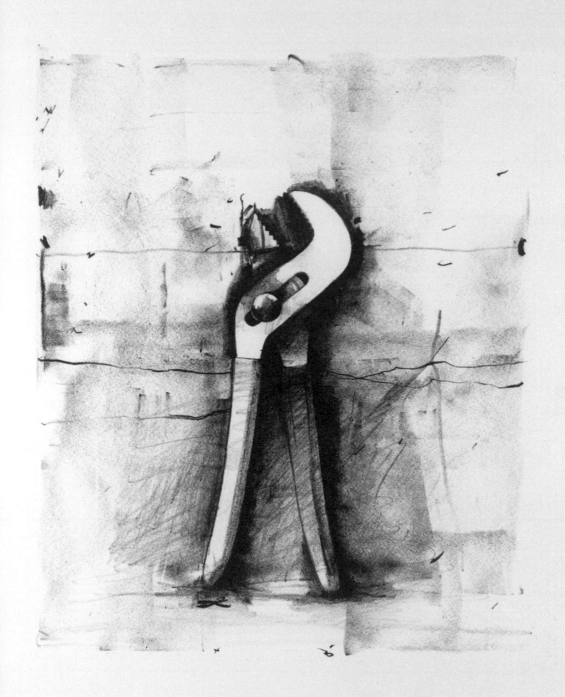

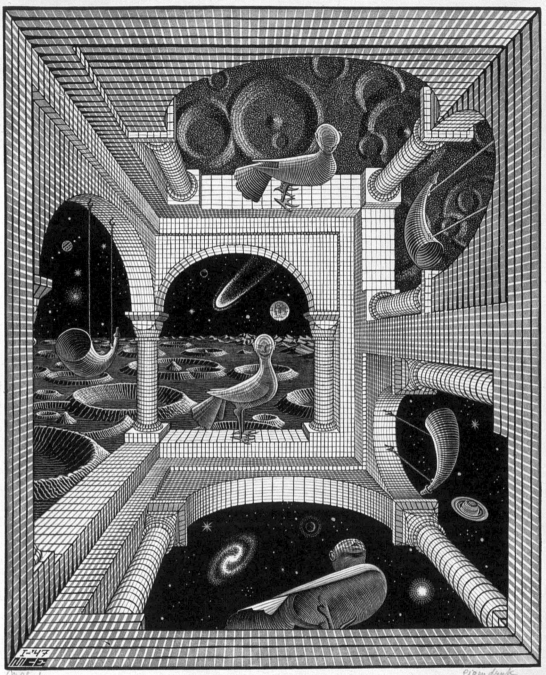

Perspective

IT'S ALL AN ILLUSION

Perspective is about illusion – an illusion of depth and an illusion of reality. It changes and manipulates. It makes the two-dimensional appear three-dimensional. It can make the mundane appear dramatic, and the important seem insignificant.

Creating a realistic illusion of depth on a flat surface eluded artists for centuries. Many recognized that objects appear smaller the further away they are, but it wasn't until the Renaissance that artists fully understood that perspective is all about the position of your eyes.

Perspective allows visual artists to tell stories and transport people to imagined worlds. And because perspective is a set of rules, these rules can be bent or broken. Dutch artist M.C. Escher, for example, created a perspectival world of seductive trickery where the possible and impossible seamlessly join.

In this section we will be practising perspective by drawing a simple cube. When you get confident with a technique, try it out on another subject. Soon you'll have the skills to become a master of illusion.

Other World
M.C. Escher
1947

Get some perspective

Perspective is an approach to drawing that a lot of Renaissance artists got very excited about when they invented it. It works in a precise and mathematical way.

You don't need to worry about all that though. The simple fact is that the rules of perspective dictate that objects appear to get smaller and/ or fainter the further away from us they get until they eventually disappear. These are the concepts behind the two systems of perspective known as linear and atmospheric perpsective.

Atmospheric perspective
With atmoshperic perspective, not only do objects appear smaller as they recede, they also become fainter. The idea is that it's the atmosphere that makes things appear fainter.

You have probably seen this phenomenon – things in the distance appear fainter than things closer to you. This is more obvious the further away the object is – mountains or buildings on the horizon, for instance.

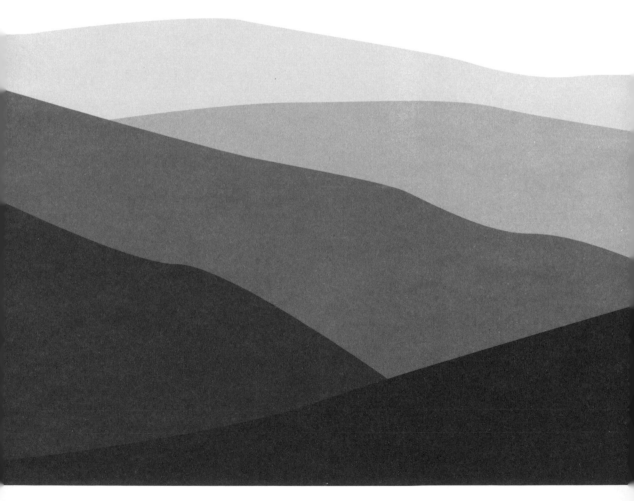

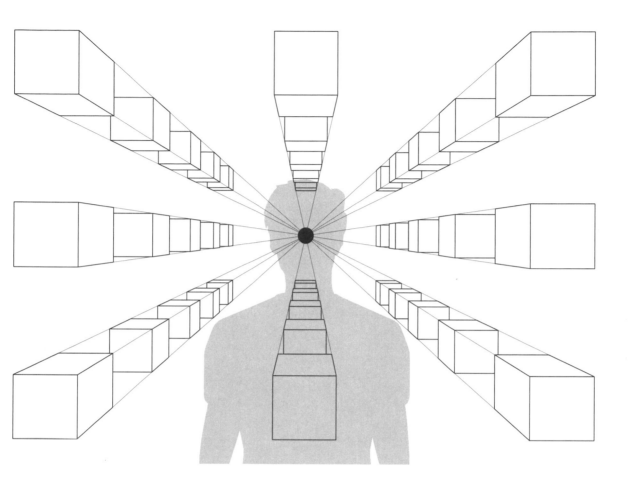

Linear perspective

Linear perspective gets its name because it's all about lines. In linear perspective objects become smaller and smaller the further away they are. And the point at which they disappear is called the vanishing point.

It is possible to have two or even three or more vanishing points, but let's begin with one vanishing point – that is, one-point perspective. The vanishing point in one-point perspective is in direct relation to where your eyes are. It's on the same line and level as your eyes. Imagine standing in a big white space with a whole load of boxes floating around, the boxes would shrink in size along an imaginary line to the vanishing point.

For the perspective to make sense, the objects have to be well ordered. The row of boxes, for instance, must run in a straight line in order for them to appear to disappear in the distance.

When drawing using only one vanishing point, draw the edges and planes facing you as parallel and the edges of the receding surfaces as converging towards the vanishing point.

It isn't always as straight forward to find your vanishing point if you are out drawing on location. They're there but they aren't always obvious. In these instances, uses your pencil to find the angles you need to create perspective. You can follow the angles down to the vanishing point(s).

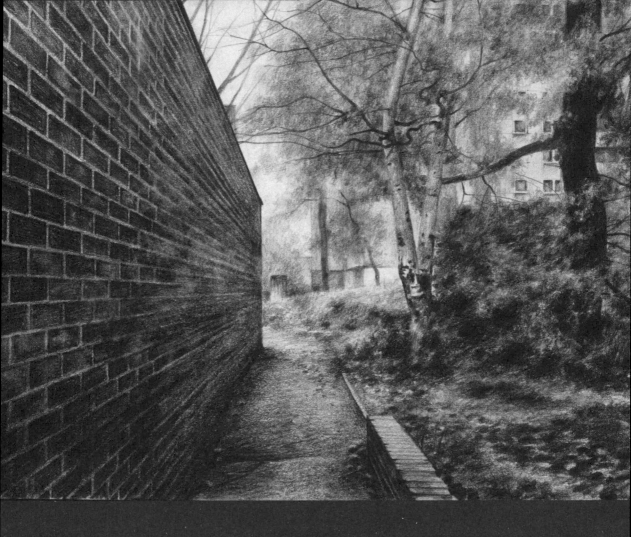

Untitled Study (1)
George Shaw
2004

For another example:
Brooks Salzwedel, p.92

Get to the point

George Shaw's work leads the viewer down the same streets and alleys that he walked when he was growing up on the Tile End Estate in Coventry. In this drawing, we see how one-point perspective turns an ordinary alley into a place of potential drama with clear, steep lines that disappear into the distance.

With one-point perspective everything gets smaller until it disappears into a single vanishing point. Here the wall, grassbank and path all do exactly that, finally disappearing at a point at the end of the path. Note how the lines of the bricks are at a sharp angle at the top of the wall then flatten out as they approach the eye-line before angling up. But no matter the angle, they lead you to the same vanishing point.

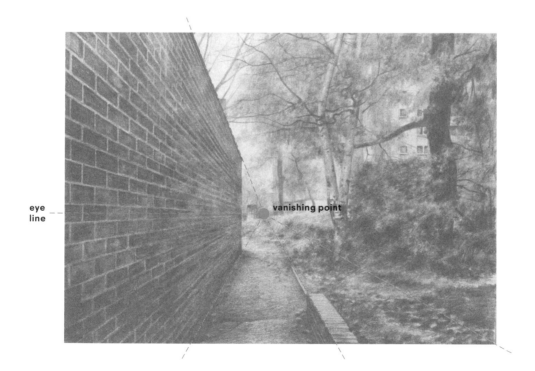

eye line

vanishing point

Approach from an angle

American artist Ed Ruscha used perspective to make everyday locations, like this petrol station, appear dramatically three-dimensional. In this drawing the steep angles of the structure thrust out of the page.

Ruscha's drawing is an example of two-point perspective. Rather than have one vanishing point in the distance, two-point perspective uses two vanishing points, which lead you out to the left and right.

You can use two-point perspective to bring the image off the page. And by drawing your subject from a very low, ground-level eye line, like Ruscha did, you enhance the three-dimensionality and make a much more dramatic image.

Try drawing your own building using two-point perspective

Draw a horizon line. Mark a dot on the left-hand side and a dot on the right.

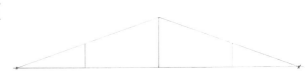

Draw a vertical line in the centre of the page, down to the horizon. Connect the top of the line to the points at left and right. To either side of the vertical line draw two further lines connecting the horizon line with the top line. These two shorter lines define the shape of your building.

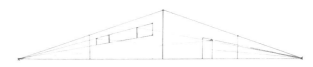

You can now start adding windows and doors and other details. Be sure their shapes follows the angles created by the horizon and top line.

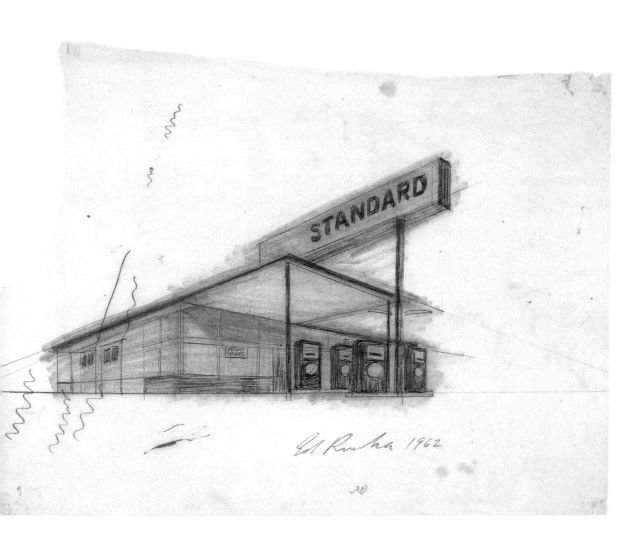

Standard / Shaded
Ballpoint
Ed Ruscha
1962

For other examples:
Iran do Espírito Santo,
p.86
Matt Bollinger, p.110

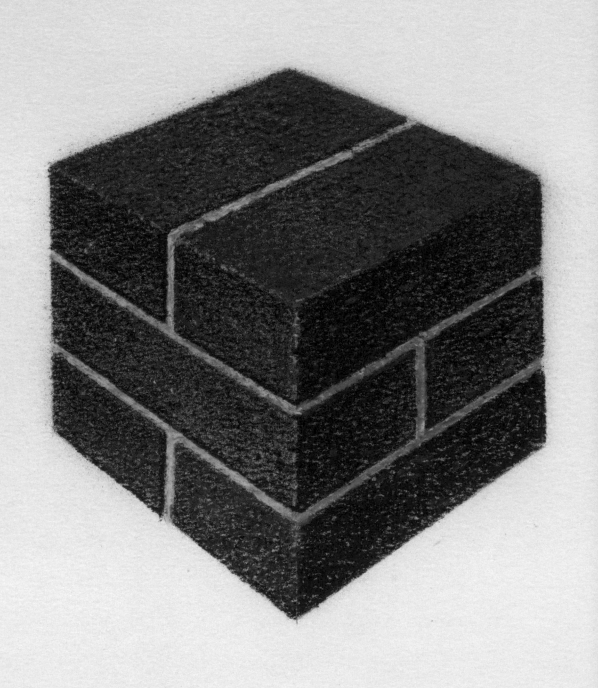

Get a little closer

Iran do Espírito Santo's drawing of beautifully detailed bricks is another example of two-point perspective. But unlike the dramatic steep lines of Ruscha's petrol station the perspective here is more subtle.

The vanishing points for Santo's bricks are a long way off to the side. In reality this is a more usual situation and is why the lines converge at a much shallower angle. The closer you are to an object, the less you see the converging effect towards the vanishing point. The edges almost look parallel.

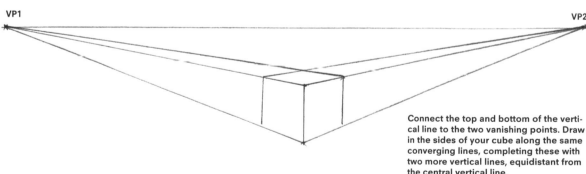

VP1

VP2

Draw your horizon line and then draw a vertical line below it. Now mark your two vanishing points at either end of the horizon line.

Connect the top and bottom of the vertical line to the two vanishing points. Draw in the sides of your cube along the same converging lines, completing these with two more vertical lines, equidistant from the central vertical line.

Finally, complete the top of the cube along the diagonal lines that connect each top outer corner with the opposite vanishing point.

Untitled
Iran do Espírito Santo
1998

For other examples:
Ed Ruscha, p.85
Chad Ferber, p.89

Take me higher

Perspective is about achieving the illusion of depth in both horizontal and vertical directions. That's why Chad Ferber's robot looms above us, with its great big feet planted on the floor and cuboid body towering into the sky.

As we look up at something tall, like a skyscraper, its parallel sides appear to converge gradually. Where are they disappearing off to? Yes, you guessed it – a third vanishing point.

Begin by drawing the horizon line low down on your page. Mark off two vanishing points on either side of this line. Now mark a point in the middle of the page at the top. These are your three vanishing points. Then add a vertical line just below it.

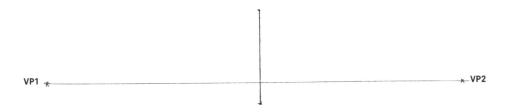

Now connect them all up!

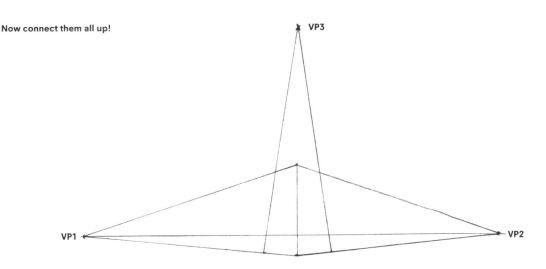

brzrk rbt 8x1001 (detail)
Chad Ferber
2003

For another example:
Iran do Espírito Santo, p.86

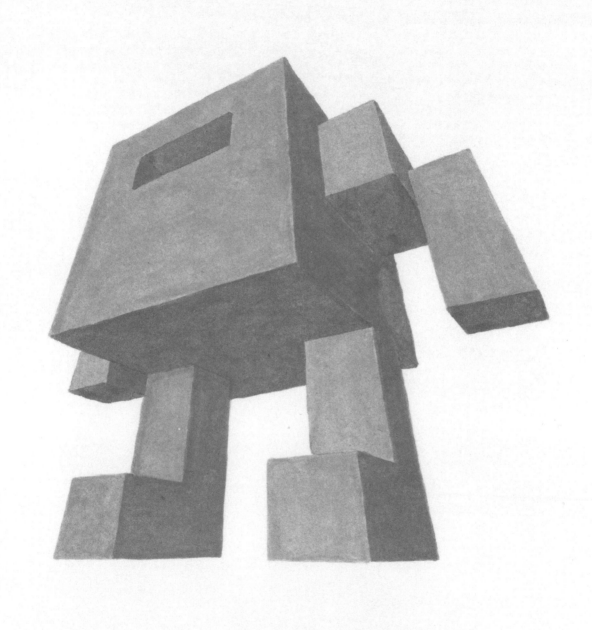

Be deep, really deep

So perspective is all about illusion. The illusion of being able to step into a picture plane, or of the picture stepping out at you. This drawing has both of these, and its dramatic use of perspective is called foreshortening.

As we look down on this figure, the trumpet seems to come out of the page as the figure's body recedes dramatically back into the distance. So this trumpeter seems to be flying up towards us.

Everything about this drawing accentuates the depth. Look at the size of the trumpeter's arms compared to his narrowing waist and legs, and the length of the torso, shortened because of the angle from which we view it.

This is how foreshortening works – the same way as one-point perspective, whereby things closer to us appear larger, and things distant are smaller. It gives drawing an incredibly dynamic feel.

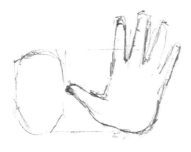

Draw a hand, fingers outstretched. Use your own for reference (try the technique on p.74). Now draw a head to the left of the hand. Make it half the size.

Fill in the upper half of the body, keeping it in proportion to the size of the head. Now with some simple curved lines, connect the hand to the shoulder.

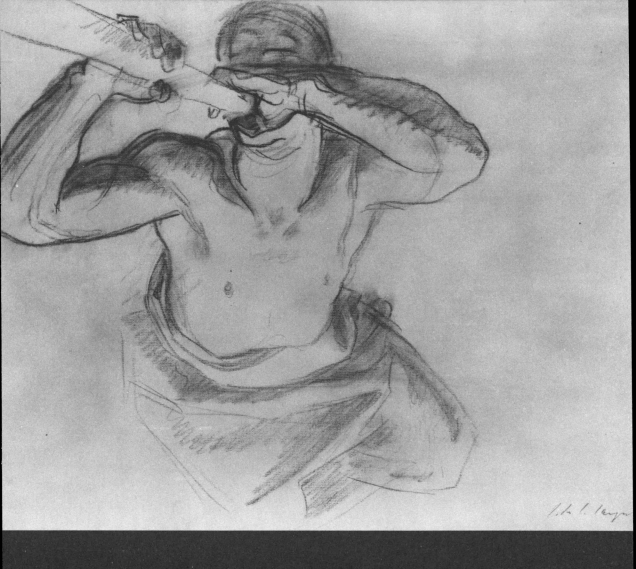

*Study for Trumpeting
Figure Heralding Victory*
John Singer Sargent
1921

For other examples:
Lucian Freud, p.40
Miguel Endara, p.51
George Shaw, p.82

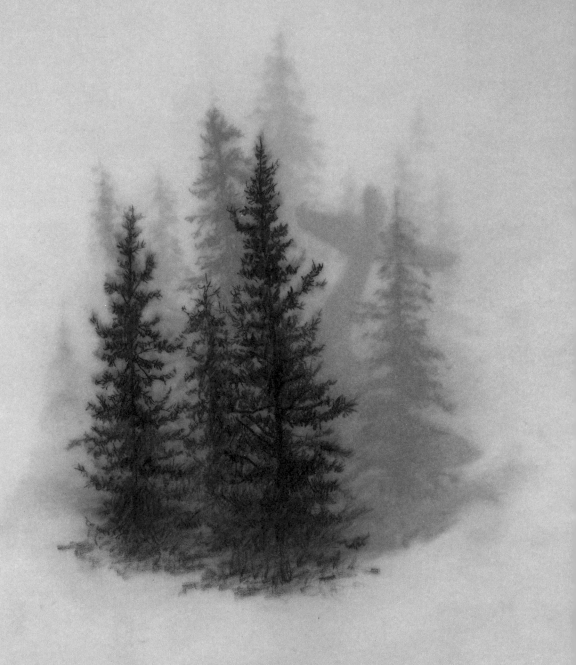

Brooks Salzwedel

Fade into the background

Brooks Salzwedel's drawing combines Romantic grandeur with a gentle intimacy. Bristling spruces stand dark and detailed in the foreground but fade into the snowy background. And then, barely visible through the trees, we see the ghostly wreckage of a plane.

You don't just need lines and vanishing points to create depth. Atmospheric perspective means things literally fade into the distance. This is done by lightening the tone of objects. In any drawing a softer line will push things further back and a darker line will bring things forward, closer to the viewer.

Here it allows Salzwedel to enhance the sense of remoteness while also drawing the viewer into the scene so that they discover its true subject. This fading is especially useful for conveying large distances – mountains in the background of a landscape, for example.

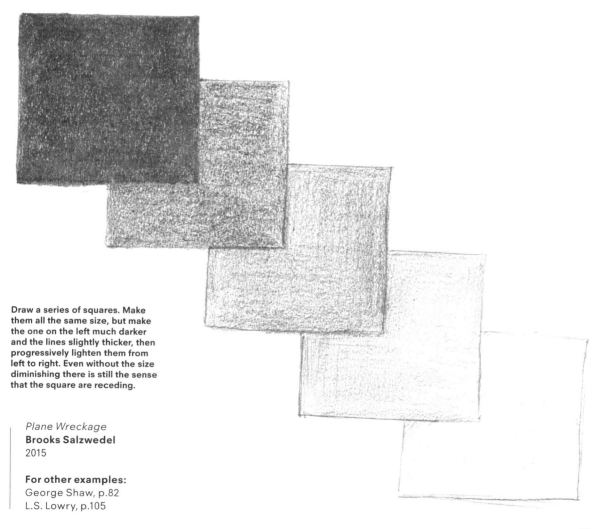

Draw a series of squares. Make them all the same size, but make the one on the left much darker and the lines slightly thicker, then progressively lighten them from left to right. Even without the size diminishing there is still the sense that the square are receding.

Plane Wreckage
Brooks Salzwedel
2015

For other examples:
George Shaw, p.82
L.S. Lowry, p.105

Bend the rules

Paul Noble's playful and intricate drawings hover somewhere between an elaborate doodle and a half-remembered dream. Here a strange structure stands surrounded by blocks. We can see that there is depth to the space, but there's something unusual in how it's depicted.

As with the Escher image on page 78, Noble doesn't stick to the 'usual' rules of perspective. Here, the lines don't converge in on any vanishing point. Instead they stay parallel. It's the 45-degree angle that implies depth.

Perspective is a set of rules that creates the illusion of realistic space, but playing with these conventions or purposely altering them can lead to exciting and unusual drawings.

Play around with Noble's technique yourself, but also don't be afraid to explore your own ways of bending the rules of perspective.

Mall
Paul Noble
2001–2

For another example:
Mattias Adolfsson, p.107

Bring it to the surface

Let's end this section with something completely different. Perspective is all about depth, but sometimes you might just want to flip that on its head, like Carine Brancowitz does with this intricate drawing. Brancowitz's drawing is about flattening everything so that it becomes a celebration of patterns. Here the back wall, the tangle of hair and the zigzag black-and-white jumper work together to make this drawing all about surface.

Brancowitz's drawings come from a rigorous observation of everyday life. Armed with a camera she captures snapshots of the things and people around her, then working from these, she makes drawings, accentuating flatness rather than a sense of space.

Working from photographs can be helpful as you are already starting with something two-dimensional. It's flat. And instead of trying to recreate the illusion of three dimensions you can concentrate much more on any patterns on the surface.

Smoke Rings
Carine Brancowitz
2011

For another example:
Mattias Adolfsson, p.107

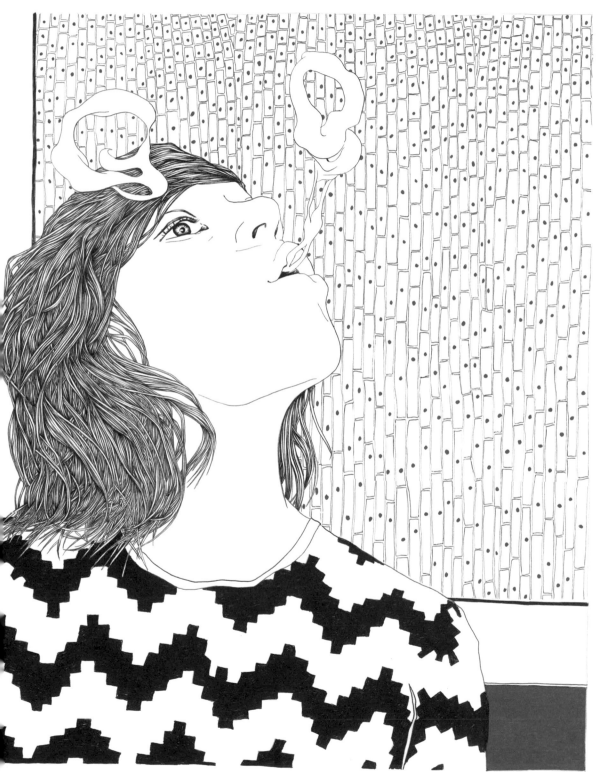

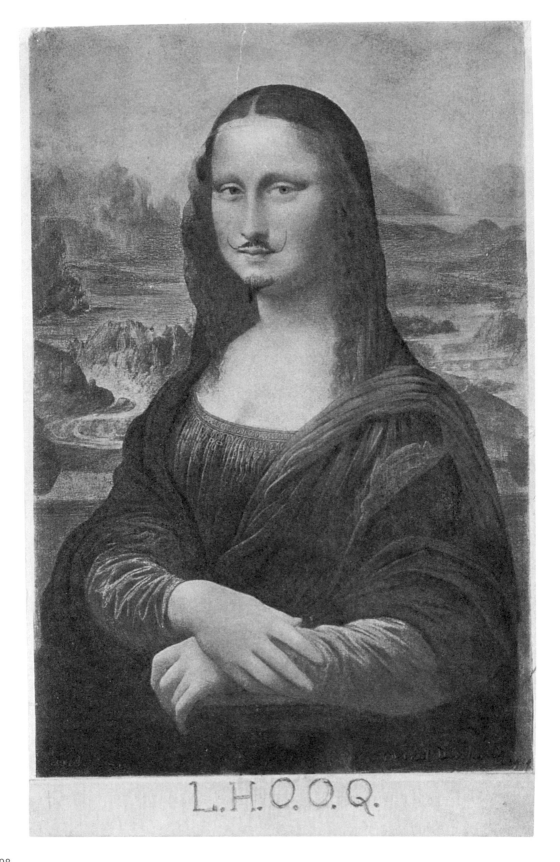

Explore

FIND YOUR OWN WAY

Each of the artists featured in this book bring part of themselves to their drawing. They decide what they want to draw and which techniques they will use. Their drawings may look accomplished, but one thing's for sure: it took them time to find their own way.

So far we've looked at different drawing techniques. Now it's time to tackle the big question; what are you getting down on paper and why. The more you draw, the faster you'll find the answer to these questions. Great drawing is a lifelong practice and it's a combination of looking, feeling and self-expression (not necessarily in that order). The important thing isn't to doubt yourself when it comes to your choices. Don't worry that what you're drawing might be considered by others as boring, inconsequential, weird or wacky. You're the artist, you're in charge.

Marcel Duchamp was definitely happy to go his own way. For *L.H.O.O.Q.* he took a reproduction of the almost hallowed *Mona Lisa*, drew a beard on her and then gave it a title that, when said in French, means 'she has a hot arse' (*elle a chaud au cul*). The drawing is simple and brave and was like a pin that burst the bubble of art at that time. It still reminds us that nothing is more important to the artist than self-expression.

L.H.O.O.Q.
Marcel Duchamp
1919

What to draw?

Drawings can be of anything you want. Shapes and patterns, or drawings with no recognizable subject matter, are described as abstract, whereas drawings that present identifiable subjects are known as figurative or representational. Other drawings can hover somewhere in between.

Representational drawings have traditionally been split into different categories or genres, the main ones being landscape, portraiture, still life and the figure.

These classifications can be useful, but don't be limited by them. Don't just set out to create a drawing that fits within a specific genre. Treat these different types of subject matter as elements that you can use on their own or in combination. They're tools, not rules.

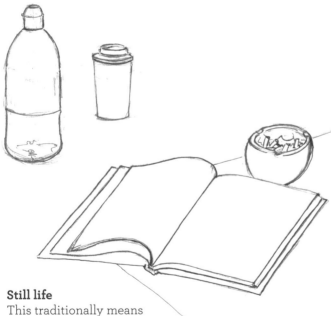

Still life
This traditionally means a single inanimate object or group of them. It can be anything – nothing is more or less important – making still life a great way to concentrate your powers of observation and learn how to transmit them to paper.

Figure
From quick, rough sketches to painstakingly detailed images, the human figure is challenging, but also incredibly fun to draw. There are so many ways to draw it, and endless shapes and movements to capture. And you needn't limit yourself to the human figure, either.

Portraiture

Capturing someone's features and personality with your pencil is not an immediately easy thing to do. It takes time and practice, but all that effort pays off. And it's a great way to develop your skills.

Landscape

This can be hills, forests and streams, or it can be the view from the room you're sitting in. It can simply provide the background of your drawing, or it can be the subject of it.

Make your mark

Vincent van Gogh was a man of intense passion. He was excited by the world around him and constantly expressed this on canvas and paper. We're all familiar with his paintings, but perhaps less so with his equally visceral drawings of similar subject matter.

Van Gogh was the ultimate visual explorer. For him, drawing and painting made sense of what he saw around him every day, and his subject matter reflects exactly that. The marks – the dots, dashes, lines and squiggles – all become a language to depict the textures of the landscape in front of him.

The Road to Tarascon
Vincent van Gogh
1888

For other examples:
Miguel Endara, p.51
L. S. Lowry, p.105

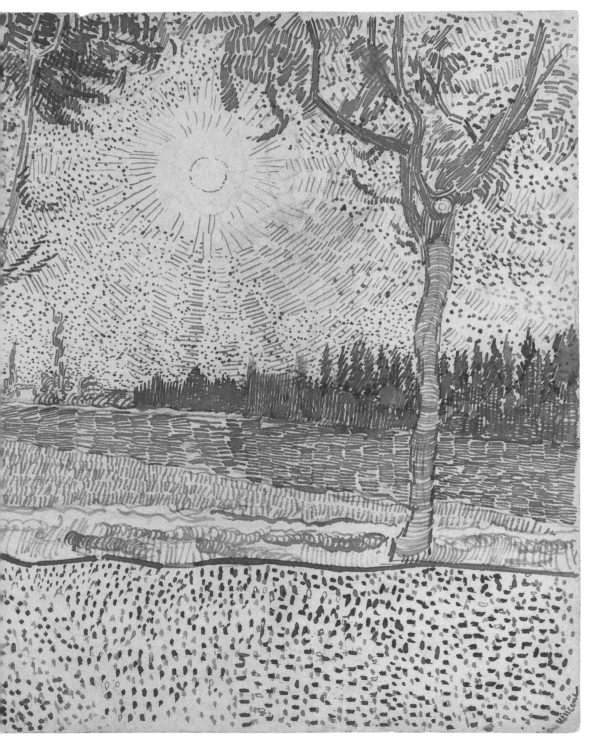

Capture your world

Sharply outlined figures stand waiting; behind them the town dissolves into a smudgy, indistinct distance. Adults, children, buildings, street – everything is grey, but in this greyness we see the colour of everyday life.

This was L.S. Lowry's world. It wasn't 'exciting', it wasn't 'beautiful' and it certainly wasn't the typical subject matter of choice for artists in the 1930s. Instead it was ordinary – a place of terraced houses, smokey chimney stacks and people going about their day-to-day buissness.

Here Lowry comunicates the individuality of each person, not with detailed faces, but with their differing poses. There is a slump-shouldered boy in the middle of the foreground who is bored of the waiting and trying to catch his mother's eye. On the left a girl seems braced for an attack from her little brother. All the while the parents take the opportunity to chat for a few moments as they wait for their newspaper.

Like Lowry, you too can become a keen recorder of the people and places from your own world, whatever or wherever that might be.

Waiting for the Newspapers
L.S. Lowry
1930

For another example:
Brooks Salzwedel, p.92

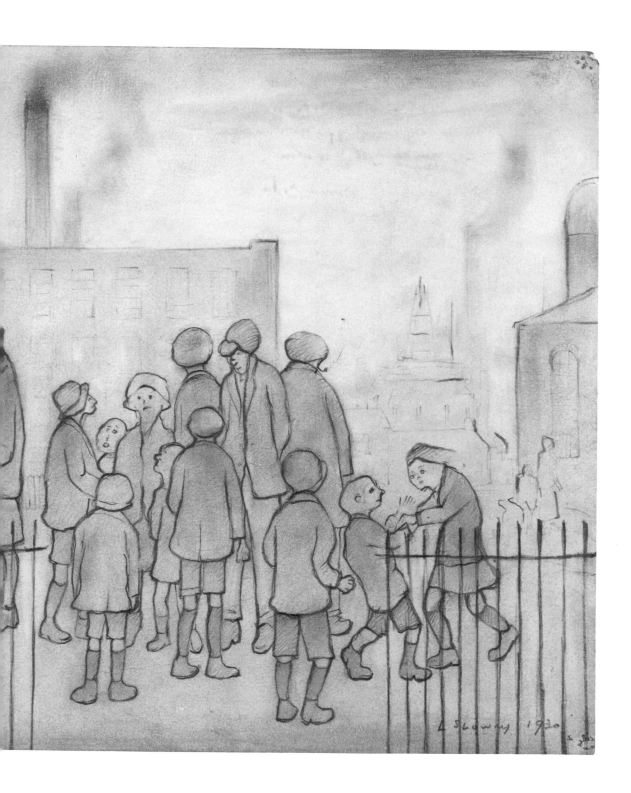

Record the detail

Busy and full of wonderful detail, it's easy to get lost in Mattias Adolfsson's room. If Lowry's drawing is about simplicity, Adolfsson's is about the beauty of complexity.

As with this drawing, Adolfsson covers the pages of his sketchbooks from edge to edge and right over the middle, every inch containing intriguing details that make up a complex whole. From the clutter on the table to the titles of the books, everywhere you look there is another clue as to the person whose room this might be.

Adolfsson's work features amazing characters busying themselves in incredible and elaborate places. The intricacy of this work reflects Adolfsson's engineering and architectural background. He lets his love for mechanics, machines and weird and wonderful structures shine through every part of his drawings.

Draw the small stuff. Look closely at your subject and put all that detail into your drawing. And don't be scared of covering the whole page.

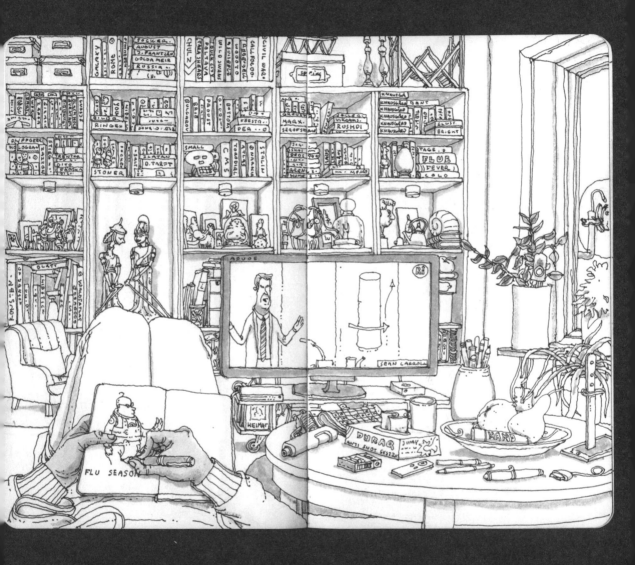

Flu Season
Mattias Adolfsson
2016

For another example:
Carine Brancowitz, p.97

Find your happy accident

Great drawings go hand in hand with great stories, and Quentin Blake's distinctive spiky style has brilliantly visualized the words of some of the best storytellers of the twentieth century.

This illustration shows two young men, Charles Ryder and Sebastian Flyte, from Evelyn Waugh's novel *Brideshead Revisited*.

At first glance the two men seem relaxed and at ease, but there is a nuance to Blake's drawing that captures the subtle differences in their body language and expressions. The young aristocrat lies back, legs outstretched, languid and blank, while his friend sits knees up, his expression slightly uneasy.

If a picture speaks a thousand words, then a single, crucial expression or gesture in that picture must be nine hundred and ninety-nine of those. This is Blake's skill. He zeroes in on the idiosyncratic expression or gesture that sums up a character perfectly, and then works everything else around that.

Blake's drawings may look spontaneous, but they're far from it. It takes him a few attempts before he comes up with a kind of happy accident, what he calls his 'phantom felicity', with which he can proceed building his final drawing.

Every drawing's 'phantom felicity' is different. It's very personal and usually comes from a feeling or observation based on your own personality. Have a go at finding that one central expression or gesture, and then build the rest of a drawing around it.

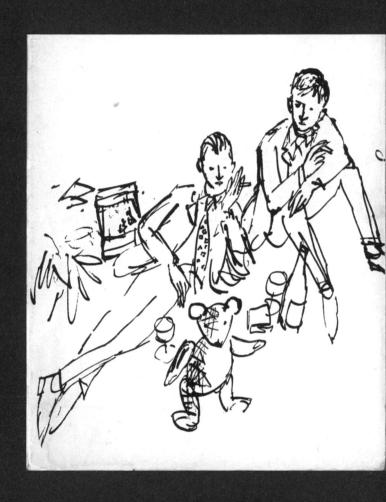

Brideshead Revisited
Quentin Blake
c. 1962

For other examples:
Boris Schmitz, p.15
Pam Smy, p.61

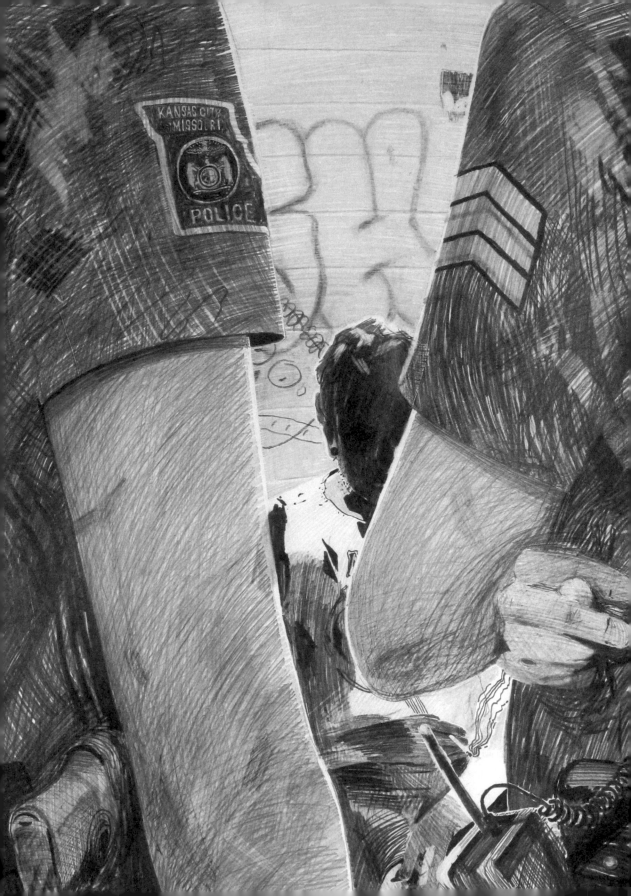

Tell your own story

Quentin Blake is a genius at bringing other peoples' stories to life, whereas Matt Bollinger is a genius at bringing his own stories to life. He does this by drawing imagined scenes that feel like stills from a movie.

What I love about Bollinger's process is that by simply picking up a pencil we can all become film directors, without any of the hassle of having to find a spare few million to make a film. In this example we see a shadowy figure framed by the arms of two cops. Bollinger leaves the rest of the story to our imagination, but guides us in a particular direction with certain visual devices: the tight crop on the backs of the police, the way their arms make a V shape that just allows us to glimpse the third figure's dark face.

Bollinger starts with a phrase or a simple story, and then builds a picture around that. Before going for the big final drawing he references images online to draw small thumbnail sketches that help him figure out where the main features should go. He then works in the details that 'ground' the image.

Working from a variety of different sources gives you more scope for creating a lifelike portrayal of your imagined scene. And working it out in a small sketch first allows you to deal with the big picture, preventing the detail from distracting you too early on.

Cops
Matt Bollinger
2015

For another example:
Robert Crumb, p.47

Push your boundaries

Matthew Barney is an artist who doesn't like his drawing to be easy. In *DRAWING RESTRAINT 15* Barney went on a trans-Atlantic journey. He used everything around him to make his work, from the boat itself to the fish caught from it. This wasn't about the drawing as a finished product, it was about the process.

Work of this sort is all about the imagination and ideas of the artist. There are no limits when setting yourself constraints and rules. With this sort of drawing you won't be in total control over how it will look in the end, which might strike you as odd, but all I will say is, don't knock it until you've tried it.

Setting parameters for your drawing takes much of the decision making out of your hands. And these parameters and constraints don't have to be physical, either. You might try drawing whatever is in front of you at the same time every day, wherever you are, or at a certain destination. You may not end up with the drawing you expected, but that's the fun of it.

DRAWING RESTRAINT 15
Matthew Barney
2007

For other examples:
Matt Lyon, p.11
Gary Hume, p.16

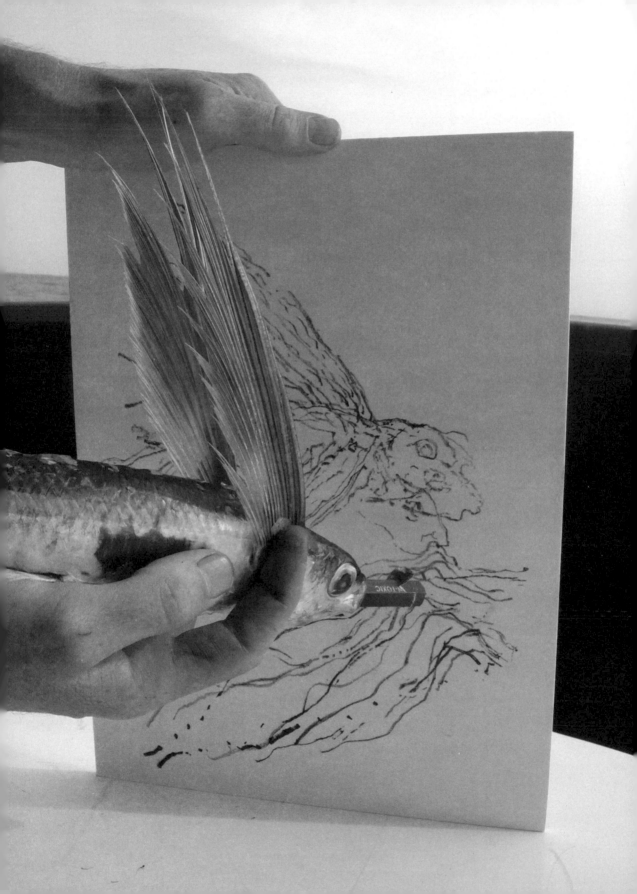

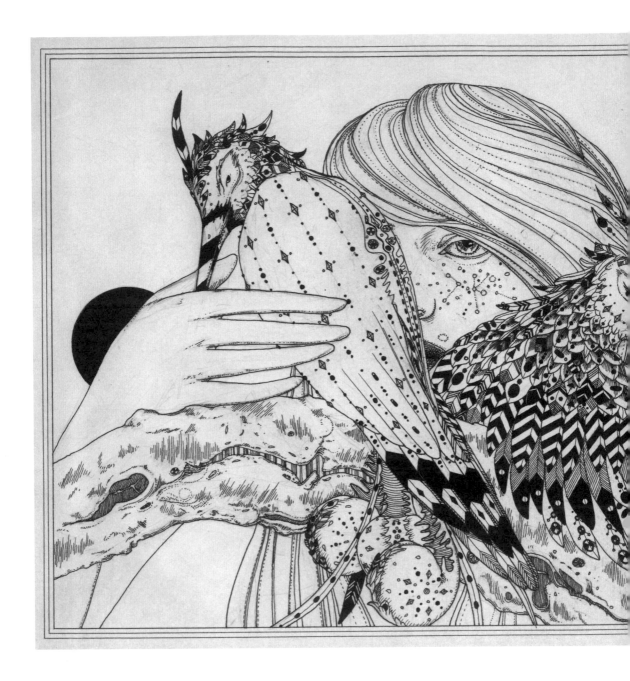

*Breathing Through
the Code*
Ernesto Caivano
2009

For another example:
Anoushka Irukandji, p.121

Be a serial drawer

Ernesto Caivano creates fantasy worlds in his drawings, where chararacters and motifs appear and disappear like threads in a huge tapestry. Each drawing is a glimpse into a mystical world entirely of his own invention.

When it comes to influences and visual references, Caivano is like a magpie. He takes things from all sorts of different places, from fractal mathematics to medieval woodblock prints. He then draws from life, from photographs and from his memory and imagination to visualize an eleborate narrative web.

Drawing doesn't have to be about a single one-off image – it can be part of a whole series. In Caivano's case each drawing is another piece in an epic, elaborate saga. As you see each drawing, the wider picture becomes clearer and the story unfolds. Drawing is simply an extension of Caivano's imagination, and he draws viewers in to see the places and people that exist there.

Create your own series of drawings with characters and a story that develops slowly. You don't have to make these drawings obvious like a comic book – instead, give them an air of mystery like Caivano does.

Mix it up

This girl's pose and attitude is reminiscent of a model in a fashion magazine, yet the delicately realistic rendering of her face is in total contrast to the stark abstract lines that make up her torso.

The mix of styles in Alan Reid's image creates a visual dynamic that clashes – it's at the same time realistic and abstract, jarring and harmonious. The ambiguity is there in how we read the drawing as well: does it draw us closer, so we try to see beneath the surface, or do we feel more detached because of the cold stylization?

The beauty of drawing is that there are no barriers to what it can be. You are free to draw anything you want, in any way you want.

Don't feel constrained to stick to just one style in a single drawing. Instead, mix it up. By doing so you can create an interesting tension that can make the viewer look closer. Contrast realism with abstraction, or experiment with constrasting tonality or lighting. Jarring juxtapositions can often bring a drawing to life.

Try picking two sections from this book at random and employing the techniques they discuss in a single drawing.

Shakespeare Performed
Nude
Alan Reid
2013

For another example:
Odilon Redon, p.53

Re-use and deface

You don't always need to start with a blank page. Here Jake and Dinos Chapman have drawn a playful scene of a family of cats taking a bath, taken from a children's colouring book, on an original early nineteenth-century print by Spanish artist Francisco de Goya. This simple transformation adds a contemporary twist that brings the past to life.

Never shy from controversy. The Chapmans, who owned a complete set of Goya's 80 'Disasters of War' etchings, took these beautiful, graphic pieces of work describing the horrors of war and quite simply drew on top of them.

These additions, or as they called them, 'improvements', show that the Chapmans don't believe any reverence needs to be shown to the past. In this moment it's their creativity that's most important. These overlaid drawings prompt us to readdress the values and systems that we live by.

Every image tells a story, and working on top of a found image or even one of your old drawings allows you to reinforce or undermine cultural stereotypes, or simply to obliterate the past and create history in your own way.

Gigantic Fun
Chapman Brothers
2000

For another example:
Marcel Duchamp, p.98

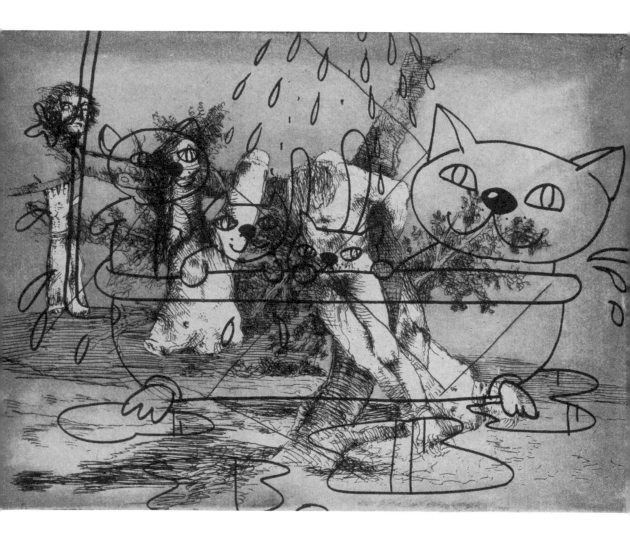

Take it off the page

Drawing isn't always just about the sketchpad and pencil. You can take it off the page as well. Of all the wonderful things you might decide to draw on, one of the most tried and tested surfaces is the human body.

That's what Anoushka Irukandji does for her beautiful, elaborate henna designs. Unlike regular tattoos, henna tattoos aren't permanent, but they last long enough for people to see and enjoy the elaborate and painstaking work that goes into them. Mixing her pigment with lemon juice, sugar and essential oils, Irukandji's designs curve and wrap around the form of her model.

Drawing on the body or any surface other than a piece of paper brings a whole different dimension (literally) to your work. You need to be careful about who and what you draw on, and accept that your work isn't necessarily going to be permanent, but that's fine.

Henna design
Anoushka Irukandji
2016

For another example:
Ernesto Caivano, p.114

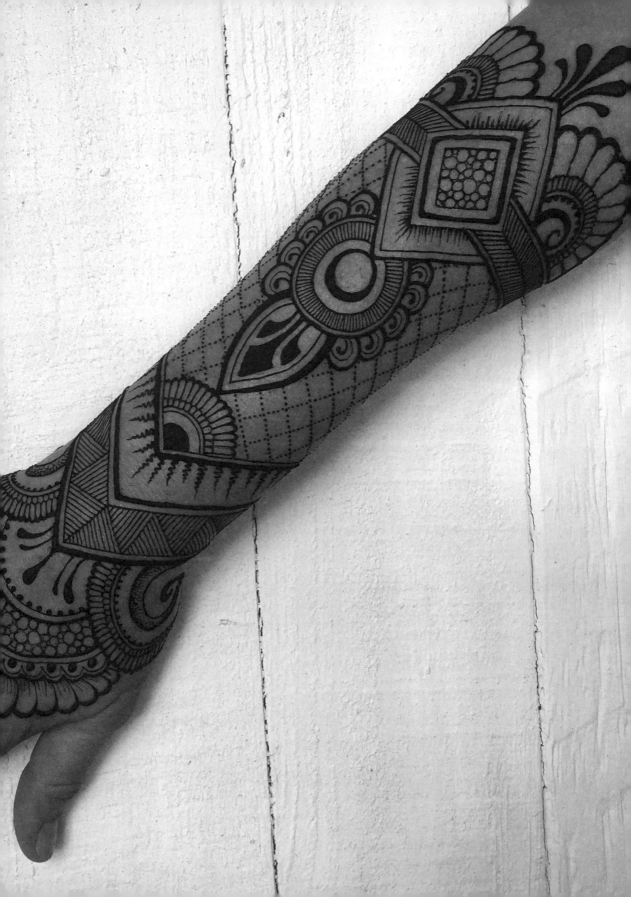

Be brave, be simple

One line. One simple line that twists and bends like a piece of wire. Looks simple, but by now I hope you know it's not.

This camel is part of a series of single-line drawings that Pablo Picasso made of a whole menagerie of animals. The subtle quality of these curves have the surety of an artist whose confidence and mastery has come from years of looking and recording.

Picasso admired the simplicity of children's drawings and this affinity with childhood mark-making stayed with him throughout his life. That's not to say he drew like a child, though, because even his most 'rudimentary' drawings, like this one, resonate with skill and proficiency. There's no ounce of hesitation or fear in this drawing. It's the result of pure joy.

All of this skill came from practice, and an attitude of not caring what people might think or how things might go wrong. Be fearless like Picasso, and remember what he said:

'To know what you want to draw, you have to begin drawing...'

Camel (A detail of preparatory drawings for the *Demoiselles d'Avignon* from the 13th sketchbook)
Pablo Picasso
1907

For another example:
Elsworth Kelly, p.31

Index

*Note: page numbers in italics
refer to illustrations.*

A

accuracy 59–78
Adolfsson, Mattias: *Flu
 Season* 106, *107*
angles 62
atmospheric perspective
 80
Auerbach, Frank:
 *Portrait of Leon
 Kossoff* 54, 55

B

Barney, Matthew:
 *DRAWING
 RESTRAINT 15* 112,
 113
Bisttram, Emil: *Self-
 Portrait* 42, *43*
Blake, Quentin:
 Brideshead Revisited
 108, *109*
blending 52, 56
blending tools 37
Bollinger, Matt: *Cops*
 111, *111*
Brancowitz, Carine:
 Smoke Rings 96, *97*
brevity 18
Bryan, Sue: *Edgeland V*
 56, *57*

C

Caivano, Ernesto:
 *Breathing Through
 the Code* 114–15, 115
Carr, Matthew: *Head*
 72, *73*
cartridge paper 22
Chapman, Jake and
 Dinos: *Gigantic Fun*
 118, *119*
contour shading 49
cross-hatching 46
Crumb, Robert: *Portrait
 of Jack Kerouac* 46,
 47
curved lines 21

D

De Feo, Michael: *Flower
 Icon* 12, *13*
Delacroix, Eugène 18
Dine, Jim: *Untitled* 76,
 77
doodles 10
dots 50
drawing tools 36–9
Duchamp, Marcel:
 L.H.O.O.Q. 98, 99
Dürer, Albrecht: *A
 Greyhound* 58, 59

E

Endara, Miguel: *Wake Me* 50, *51*
erasers 36, 55
Escher, M.C.: *Other World* 78, 79
exploring 99
eye-line 83

F

faces 72
fading 93
fantasy 115
Ferber, Chad: *brzrk rbt 8x1001* 88, *89*
figures 64, 100
fixative 36
foreshortening 90
formats 22
Freud, Lucian: *Apple* 40, *41*

G

Gaudier-Brzeska, Henri: *Tree on the Crest of a Hill* 44, 45
geometry 74
Giacometti, Alberto: *Three Apples* 28, *29*
Goya, Francisco de 118
guidelines 68, 70-1

H

hatching 45–8
Head, Howard: Design for oversized tennis racket 69
Hokusai: *Studies of Animals* 74, *75*
Howard, Sabin: *Anatomical Study* 64, *65*
human face 72
human figure 64, 101
human hand 74
Hume, Gary: *Untitled (Flowers)* 16, *17*

I

Irukandji, Anoushka: Henna design 120, *120-1*

K

Kelly, Ellsworth: *Apples* 30, *31*
Kentridge, William: *Untitled Monkey Silhouette (Talukdar)* 24, *24-5*
knives 37

L

landscape 101
Leonardo da Vinci: Solid Campanus sphere, from *De Divina proportione* 34, 35
Lewis, Wyndham: *Seated Woman with Beads* 8, 18
linear perspective 81
lines 14, 21, 28, 123
looking 28, 30
Lowry, L.S.: *Waiting for the Newspapers* 104, *104-5*
Lyon, Matt: *Taxonomy Misnomer* 10, *11*

M

marking out 68
Matisse, Henri: *Church in Tangier* 18, *19*
measuring techniques 64, 66-7
memory 26
models 33
Moore, Henry: *Two Figures Sharing the Same Green Blanket* 48, *49*
Muenzen, Gregory: *Passenger Reading a Newspaper on a Rush Hour Broadway Local Subway Train* 32, *33*

N

negative space 76
Noble, Paul: *Mall* 94, *95*

O

objects 76
one-point perspective 83
overlaying 118

P

paper 22
pattern 96
pencil grips 20
pencil sharpening 38
pencils 36, 39
perspective 79–97
Picasso, Pablo: *Camel 122*, 123, *123*
planning 60
portraiture 33, 72, 101
proportions 64, 66–7, 72

R

rapid drawing 18
Rauschenberg, Robert: *Untitled* from 'From Memory Draw a Map of the United States' 26, *27*
Redon, Odilon: *Two Pears* 52, *53*
Reid, Alan: *Shakespeare Performed Nude* 116, *117*
rubbing back 55, 56
Ruscha, Ed: *Standard / Shaded Ballpoint* 84, *85*

S

Salzwedel, Brooks: *Plane Wreckage 92*, 93
Santo, Iran do Espírito: *Untitled 86*, 87
Sargent, John Singer: *Study for Trumpeting Figure Heralding Victory 91*
scalpels 37
Schiele, Egon: *Crescent of Houses in Krumau* 62, *63*
Schmitz, Boris: *Gaze 466* 14, *15*
shading 36, 41–2

shadow 41
shapes 42, 74
Shaw, George: *Untitled Study (1) 82*, 83
silhouette 24
simpicity 12
single-line drawings 123
sketchbooks 22–3
sketching 33
smudging 52, 56
Smy, Pam: Sketchbook pages 60, *61*
starting out 68, 70–1
still life 100
story telling 111, 115
straight lines 21
subjects 100

T

Takahashi, Hisachika: *Untitled* from 'From Memory Draw a Map of the United States' 26, *27*
tattoos 120
three-point perspective 88
tone 35–58, 93
tools 36–9
two-point perspective 84

V

van Gogh, Vincent: *The Road to Tarascon* 102, *102–3*
vanishing point 81, 83, 87

W

watercolour paper 22

ACKNOWLEDGEMENTS

I'd like to thank Henry Carroll for making this possible and for his guidance throughout; thank you to everyone at Laurence King Publishing, especially to Jo Lightfoot, Ida Riveros and my editor Donald Dinwiddie whose patience was incredible; thanks to James Lockett at Frui (www.frui.co.uk) for his advice and help; thank you also to Keith Day and Peter Sheppard for their constant support and thanks finally Natalie Kavanagh, Brenda Vie, Eve Blackwood, Gerry Cirillo and David Lydon at Hampton Court House, for all their assistance.

CREDITS